THE FORGOTTEN ARTS

Yesterday's Techniques
Adapted to Today's Materials

Book Three

by Richard M. Bacon

YANKEE®BOOKS

Camden, Maine

Clarissa M. Silitch, Editor
Carl F. Kirkpatrick, Art Director
Ray Maher, Illustrator
Margo Letourneau, Illustrator
Debra McComb-Wright, Illustrator

First Edition
Copyright 1976, by Yankee Publishing Incorporated
Printed in the United States of America
Seventh Printing, 1991

Library of Congress Catalog Card Number 75-10770
ISBN 0-911658-71-8

Contents

Foreword

The Forgotten Arts articles have been so well received by *Yankee* readers that here is the third volume in the paperback series by R. M. Bacon. There is something very elemental in the appeal of the subjects with which the writer deals, a practice or an idea many of us may have observed but hesitated to attempt or embrace. In this book the author brings to our attention arts from all levels of a more direct time — something as basic as feeding a family through the winter required a knowledge of how a root cellar functions, or knowing how stark floors could be brightened with painted patterns rather than expensive rugs — skills worthy of wider remembrance.

Perhaps our interest is drawn to these skills because they connect us with that earlier period, possibly no further removed than our grandparents' generation, but a time when the nature of work was varied. Success was not always measured by dollars received; it could just as easily have been a strong, functional basket of woven ash. Whether or not that basket was ever sold was not important, a measure of the craftsman was carried in that basket, his work rewarded each time the container was filled and emptied as it was designed to be.

As fewer people find honest satisfaction in their work, more reach out in other directions, often hoping to find a purpose such as Robert Frost suggests can be discovered by striving " ... to unite/My avocation with my vocation/As my two eyes make one in sight." There is a wealth of enjoyment by doing in these pages, explanations of how to reward yourself with a job worth doing.

This past March I pruned the two ancient and overgrown Baldwin apple trees that guard my front lawn, following the guidelines set forth by Mr. Bacon. There will be no fruit this year — the two trees were badly outsized and consequently received drastic pruning — but already (it is July now) I am optimistic about next year. The new growth on the trees is extraordinary, they are luxurious in their promise for the season to come.

A few hours labor in the winds of March will be rewarded by a harvest of apples next fall. There was pleasure in the performance of the task, but my interest in the work will be compounded tenfold by next September. Surely learning a skill that is a pleasure to use is an art worth remembering.

John B. Pierce
Yankee Magazine

Courtesy Plimoth Plantation, Plymouth, Massachusetts

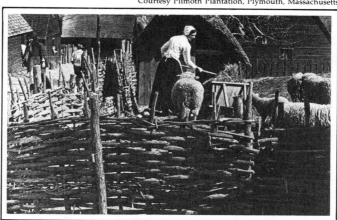

Portable wattle fences were used by our earliest settlers.

Making Wattle and Other Portable Fences

WHEN MAN FIRST DOMESTICA-ted animals for his own use, he automatically created a problem — how to keep them in their place. And on today's homestead good fences are a major but necessary investment, if one wants to keep his livestock safe and maintain good relations with his neighbors. As the costs of barbed wire, woven stock fencing, and electricity soar, more countrymen are turning to their own woodlots to help solve the fencing problem.

One way of confining and segregating small stock is to build movable sections of fencing that can be set up and rearranged quickly. When not in use, these portable wooden fences can be stored under cover, thus extending their useful life for years.

It would be futile to try to confine large animals — cows or horses, or even barnyard fowl — with portable, lightweight fences. But small stock — geese and turkey poults, replacement poultry and even orphaned lambs — can be controlled with a portable fence as the need arises. Sections can also be used for aged sheep during lambing, to divide the flock at breeding time, or for individual treatment such as shearing and worming.

The wattle fence was developed centuries ago and has undergone few changes. It can be built in 6- to 8-foot sections with only a few basic hand tools: the ax and billhook for cutting stock; the adze, froe and beetle for splitting and shaping; and the

brace and bit for drilling holes.

Wattle is an ancient word that means to weave or plat. Thus this kind of fence is made by weaving flexible branches (rods) or cleaved stock in and out among stronger uprights. The dimension of the rods will determine whether or not they should be split. If they are too thick to bend comfortably, you will have to split them lengthwise.

Materials for making a wattle fence can come either from a well-managed woodlot (see *The Forgotten Arts*, Book One, by Richard M. Bacon. Yankee, Inc., 1975. pp. 6-10.) or from gleanings of second growth at the edges of meadows and shrubs from marshy areas.

Wattles should be made in uniform sections that are sturdy but easily handled. Traditionally the material was cut, sorted, and stacked to dry during the winter when the sap was down. Then the sections were assembled in the summer, right in the woods where the supplies had been left.

It takes very little time to make a section once you have prepared a fence form — this speeds the job and assures uniformity of each length. As the diagram shows, the form should be a slightly curved 8-foot log, split (see p. 8, a.). Lay the flat side on the ground and bore 10 holes through the form about 1½ inches in diameter and spaced equally along the length of the log. The curve is important because when the section is removed from the form and laid on the ground in a stack, the weight of the other sections will straighten the curve, thus tightening the weaving and making a more durable fence. If a properly curved log cannot be found, use a plank 12 inches wide and 6-8 feet long. Mark it with a gentle curve along which you bore your holes with the brace and bit.

English crofters depended on ash saplings or split ash for the uprights (staves) and hazel for the rods. In this country hazel grows in shrub-like thickets, and is hard to identify in the winter woods. In the late summer hazelnuts are a good iden-

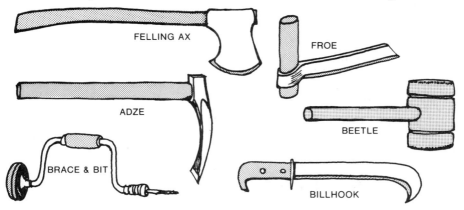

FELLING AX

FROE

ADZE

BEETLE

BRACE & BIT

BILLHOOK

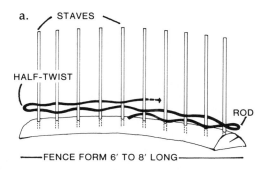

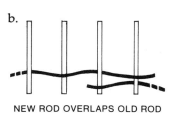

WATTLE FENCING

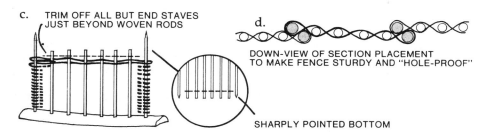

tifying mark if you can get to them before the squirrels do. But other materials are suitable: ash and cedar for the staves; willow, hop horn-beam or ironwood, and even wild grape vines for the rods. The primary requirement of this kind of fence is that it be portable, so all materials should be as light-weight as possible. Split oak, for example, although notably strong, makes a fence that is too heavy to move comfortably.

The best-looking wattle fences are made from split stock. These sections have no loose ends sticking out to mar their appearance. However, if the homesteader needs a fence in a hurry, any flexible rod that can be bent without breaking will do. Vines and shrubs can be trimmed after the fence is built and will confine stock whether or not they look tailored.

Take your tools and your fence form to the source of supply to build your wattle fence. Set the form flat on the ground, but leave enough space around it to make weaving the rods easy. Select staves that are slightly smaller in diameter than holes which you bored in the form. Set the staves upright — heads down — in the form, taking care that the end staves are stouter and longer (about 5 feet if you are building a fence 3½ feet high) than the

rest, for later they will be tapered to a point and driven into the ground to anchor the section.

Once the staves have been set, you can begin weaving. As diagrams a.to d.show, you first "let in" a rod at the bottom of the first three or four staves, weaving it in and out. Bend it around the end stave with a half-turn or twist before weaving it back. This twist will help prevent the rod from breaking. As you reach the end of each rod, let in a fresh one, weave it in and out, bend it around the end stave with a twist, and continue until you have reached the proper height. This will be about 2½ feet for young poultry, turkeys, and geese; 3½ feet for lambs and sheep. As in loom weaving, the end staves may want to slant inwards as you progress. To combat this, do not pull your rods too tight as you weave.

When the section is finished but still in the form, trim off all but the end staves just beyond the woven rods. Then lift the section off the form and lay it flat on the ground off to one side. Trim the tops of the staves as well, to where they were inserted in the form. The end staves should be sharply pointed at the bottom end about one foot below the wattle. As additional sections are finished, stack them one on top of another. This increasing weight will flatten the sections, thereby tightening them and making them more sturdy. (Professional wattle fence makers often leave a small part unwoven in the center of each section. This is done so that a pole can be inserted making it easier to carry several sections at a time.)

When enclosing an area with any kind of portable fencing, alternate the overlap of the sections as you pound them into the ground (see diagram d.). This gives the fence greater stability and eliminates the possibility of gaps between the sections.

Wattle fences can also be used as windbreaks, as a background for flower and vegetable gardens, to train pea vines, and — if made tall enough — for privacy.

Another type of homemade, portable fence is the hurdle. For this you should use split ash and you will need to learn to make mortise and tenon joints to fasten the ends of the horizontal bars into the upright staves.

The hurdle — still widely used today in rural England — is generally made in sections 8-10 feet long and 3½ feet high. Each section consists of two upright staves, six horizontal bars, and three cross braces.

To make a hurdle, split the ash stock with a froe and beetle, using the adze to widen the split as it progresses. These split lengths can be worked up green or stacked to dry. Ash splits easily because there are few knots which penetrate the trunk, and when dry, ash is light and resilient. The two upright staves are the posts of each section and should be made from thicker stock than the bars and braces.

Horizontal bars should be spaced wider at the top than at the bottom. This will thwart the natural curiosity of the confined animals. Mortise the ends of the bars into the staves. To do this, drill two holes

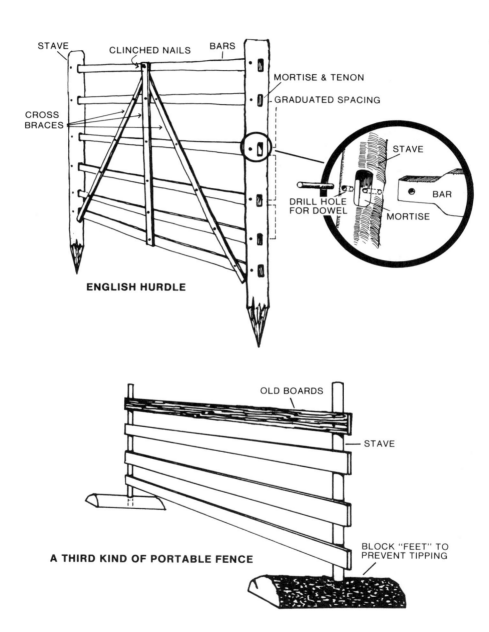

ENGLISH HURDLE

STAVE

CLINCHED NAILS

BARS

MORTISE & TENON

GRADUATED SPACING

CROSS BRACES

STAVE

DRILL HOLE FOR DOWEL

BAR

MORTISE

OLD BOARDS

STAVE

A THIRD KIND OF PORTABLE FENCE

BLOCK "FEET" TO PREVENT TIPPING

10

which at their outermost measurement will be wide enough apart to accommodate the tenon of the bar snugly. Square off the mortise with a chisel and hammer. Then shape the tenon or tongue on the ends of the bars to fit the mortise. When all the bars have been inserted into the mortises, drill a hole through the staves and tenons for each joint, and hammer in a dowel to anchor them.

You will need three braces to strengthen the hurdle: one at the center point of the hurdle parallel to the staves; and two diagonal braces which run from the top of the center brace to the bottom of the staves on each side of it. These braces can be held in place by hammering a nail through the braces and the bars where they cross. Use nails long enough so you can clinch them to keep them from pulling out.

Before you have finished each section, sharply point the bottom of the staves. As with the wattle sections, hurdles should be set up alternating the overlap of the sections to give additional strength to the portable fence.

There is a third type of movable fence which resembles the hurdles trackmen use in races. However, these sections are not as easily moved and are of use mainly to sheepmen who want to control grazing. They are constructed of two uprights set into "feet" — heavy rectangles of wood, often split logs — like the bases of early Pilgrim harvest tables. The uprights are joined by boards or split stock nailed at graduated intervals. The finished sections will be heavier than either the wattle or hurdle fences. Usually, these are lined up end-to-end to section off parts of a larger fenced pasture.

Using raw materials around him, the homesteader can make portable fencing that will be used for many years, and help keep down at least one of the costs of keeping animals.

References

Martin, George A. *Fences, Gates and Bridges — A Practical Manual* (original edition published in 1887), The Stephen Greene Press, Brattleboro, Vt., 1974.

Sloane, Eric *A Reverence for Wood*, Ballantine Books, Inc., 1965.

— *A Museum of Early American Tools*, Ballantine Books, Inc., 1964.

Reclaiming an Old Apple Tree

HOW TO EXTEND THE LIFE OF AN old apple tree — or even a small orchard — and bring it back into production is a concern of many new property owners. Although commercial orchardists think that any tree nearing forty is at the far end of its paying life, the one you have inherited may be more than twice that age and still not ready to give up. Often it only needs encouragement to produce.

There are two kinds of tree you might consider reclaiming: the one in your yard for home use and the one in the woods, either "volunteer" or planted before nature took over, whose fruit is consumed by wild life. The procedure for rejuvenating is the same for both kinds; how far you pursue it will depend on your purpose.

So, before sawing down an unsightly but still sound tree, consider some of the things you can do to improve it without calling in experts.

PRUNING

Begin by pruning. The practice of cutting out unwanted growth not only makes the tree more manageable, but opens up its branches to sun and ventilation, regulates its shape, and increases its production. None of the other steps in reclaiming an old tree will be effective without proper pruning.

The only tools you need for this job are pruning shears, a fine-toothed tree saw, and a ladder.

Before you start cutting, survey the tree's shape from all angles.

Dead, diseased or broken branches can be removed at any season of the year, but prune living branches in April and May before the leaves are fully developed so you can see what you are doing. Summer pruning (aside from removing annual unproductive watersprouts and suckers) is not recommended because it will reduce the current yield.

Most old trees are standards — tall growers to begin with — that, through neglect, have been allowed to become even taller. This eventually makes them impossible to tend effectively. In pruning these trees, therefore, you should first aim at reducing height and then at shaping lateral growth.

Lowering the tree can be done either by cutting out the center or reducing its leader and terminal growth only. Usually a combination of both methods is desirable. However, each tree presents individual problems.

After surveying the tree, decide how tall you want it to be, and cut a pole to that height: 15, 20, or 25 feet, for example. Stand this up next to the trunk to serve as a guide. With your pruning tools, cut off all growth that exceeds this marker.

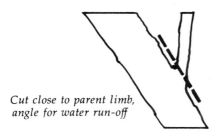

Cut close to parent limb, angle for water run-off

All pruning should be done with sharp tools. Make cuts as close to the parent limb as possible and angled so as not to catch rain. Cuts larger than 1½ inches in diameter should be coated with a substance that will seal the wound: wax, house paint, or any non-penetrating, waterproof material.

Major pruning should be done just before or just after winter dormancy is broken. The tree's sudden spurt of life helps the wounds to heal more quickly.

Now you are ready to correct the overall shape. Decide how far you want the tree to spread laterally. Tackle the lowest limbs first and prune back lateral growth all around the tree at the same distance from the trunk on each limb. Then work upwards, pruning each successive lateral layer a little closer to the trunk. You should aim for a finished shape that suggests a cone.

Even after the desired height and shape are established, you will want to remove interior growth in areas that are too thick. Thinning out old watersprouts and suckers will promote better fruiting. Do not nip off those little twigs that line the branches; the fruit develops on these tiny laterals.

Sometimes you will find that an untended tree, particularly one in the woods or at the edge of a pasture, has two or more central trunks. You should reduce this to the one best trunk by removing the others. If the tree was set out — not a native volunteer — one of the trunks will probably produce an old-fashioned name variety of apple; the others will be overly

13

developed root suckers that may or may not bear the same variety. If you want to determine the variety, let the growing season continue and harvest apples from several different areas of the tree. Often the horticultural department at your state university will be able to identify the variety if your neighbors cannot.

New England farmers rarely set out fruit orchards in the blocks of trees we know today; cleared land was too precious. Fruit trees were planted in areas where the land prohibited cultivation: along the stone walls fencing the fields, lining the cow lane from the barn to the outer pastures, and near rock piles heaped up when the land was cleared. Browsing stock accomplished much of the lateral pruning.

Some of the most challenging trees to reclaim today are lost in thickets of brush that have grown up on land that was once open pasture. Many of them will have come up wild and will bear apples that are either sour or bittersweet. But they can be pruned and will provide feed for wild animals: deer, grouse, rabbits, squirrels, and birds.

FERTILIZING AND MULCHING

All plants benefit from the stimulus of plant food supplements occasionally. This can be provided apple trees by applying commercial fertilizer or barnyard manure in a band around the tree along the drip line where the feeder roots are concentrated. If the old tree is growing on the lawn or at the edge of the garden, it will not need more fertilizer than is given the surrounding area. Do not apply fertilizer the same year you have done major pruning. However, each subsequent spring you may want to spread three pounds of calcium nitrate around the tree.

Laying a deep (one foot or more) bed of mulch will also help the tree if it can be applied conveniently. Mulch (old hay, bark, etc.) from the base of the trunk to the drip line will help conserve moisture and should be renewed as it rots to prevent weed growth. However, straw mulch often encourages rodents to nest and feed near the base of the tree in the winter. The trunk should be checked periodically for possible damage and, if noted, you should set traps and poison baits. For young trees it is essential to surround the base of the trunk up to the projected snow line with wire mesh to prevent mice from girdling the trunk and causing the tree to die.

SPRAYING

Each homeowner must decide for himself whether or not to embark on a regular spray program that will encourage higher-quality apple production and keep the foliage healthy. A continuous debate rages today between environmentalists who tend to condemn any spraying

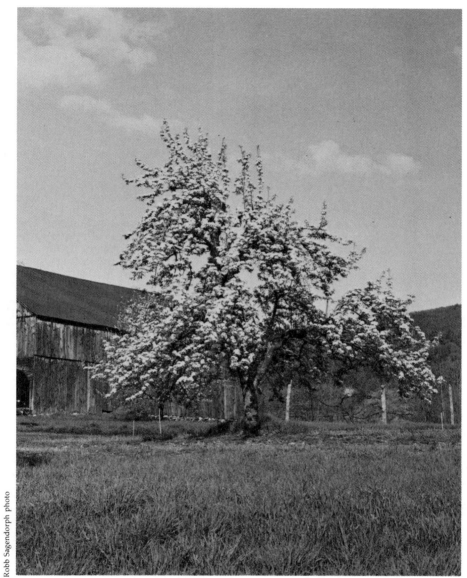

Robb Sagendorph photo

An overgrown "standard" apple tree that badly needs pruning.

out of hand and commercial growers whose livelihood is dependent on producing the blemish-free, high-quality fruit that consumers demand.

A federal law with a four-year implementation date that has been extended one year was passed in 1972 and establishes standards for the use of pesticides in all 50 states. It divides sprays into two categories: restricted and general use. The former are stronger, more effective, and usually more dangerous to man and the environment. Permits to use restricted pesticides will be issued only to those who have taken a no-charge refresher course and an examination. These courses are conducted by state cooperative extension services on a county-by-county basis.

The question of whether or not to spray will affect the home producer of apples — who can still buy general-use pesticides from garden centers and farm suppliers — less than his commercial counterpart. There is little doubt that carrying on some kind of spray program to control insects and diseases will result in bigger and more salable fruit. Talk the spraying question over with your County Agent.

Still, the homesteader who wants a supply of fruit for his own use only might better direct his energies towards educating his family to eat good-tasting apples that might be misshapen, wormy, or covered with scab.

If you decide to spray, the only equipment you will need is a simple attachment to your garden hose which gives good results.

GRAFTING

Grafting is still another — and perhaps the ultimate — way to give new life to your old tree. It may also introduce you to a fascinating avocation. This art was practiced widely by farmers before large-scale commercial nurseries made it a science. It is still the principal way of propagating apple trees and programming the size of the trees at maturity.

Grafting unites a part of one plant (scion) to another (stock) and keeps them in place until they grow together to form a single plant. It is best done at the beginning of or during the growing season when the bark "slips" or is loose enough to be worked. The scion is a bud or portion of stem which is fitted into the stock — the rooted or supporting part of the second plant — so that the cambium layers of both are in close contact. The cambium lies between the bark and the wood.

Many types of grafts have been developed to meet different situations. For the neophyte, however, budding and whip grafting are usually sufficient. Bridge grafting is also used when it is necessary to bypass damage to the trunk caused by rodents or garden implements. This technique can save an established tree.

To graft an old tree you will need a thin-bladed sharp knife, pruning shears, asphalt grafting compound, and a supply of rubber bands or adhesive tape.

A supply of scions can either be cut from living trees or purchased

from a commercial nursery. These must be in the dormant state and stored carefully so as not to dry out until ready to use. Twigs about a foot long and the diameter of a pencil are best.

To whip graft: Use scions that are equal to or smaller than the diameter of the stock. Make a sloping cut through the scion about 1½ inches long. Make a slit about ½ inch long into the surface of this cut. Cut each scion about 4 inches long so as to include 3 or 4 buds. Prepare the end of the stock in the same way. Join the two parts by slipping the tongue of the scion into the tongue of the stock. Wrap the graft firmly with rubber bands or tape, and ap-ply a compound to make this junction airtight and watertight. This should be removed as soon as the scion has started to grow.

To bud graft: Select a twig of this year's growth with well developed buds just before you are ready to make your grafts. Cut as many buds from this as you are going to use by up-ending the twig and beginning your cut about ½ inch below the bud and ending about ½ inch above it. The cut should include a small amount of wood. Remove the bud from the twig, trim off the leaf, and leave about ½ inch of stem to use as a handle. Now choose the place on the stock that is to be grafted. Make a T-shaped cut in the bark of the

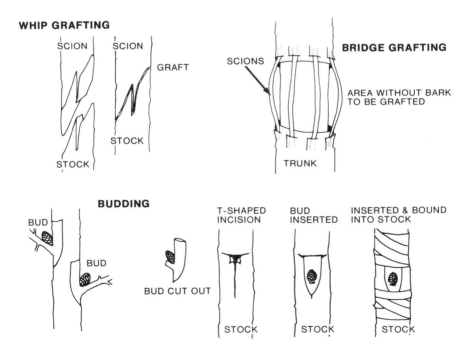

17

stem and loosen its edges with the point of your knife. Insert the bud into the cut and push it downwards so that the bark of the stock covers the bark of the scion. Wrap the graft firmly above and below the bud. No compound is usually necessary. In about two weeks when the graft has taken, cut the binding on the back of the limb and the following spring prune the stock just above the new bud.

To bridge graft: Ordinarily this is done only when the tree's life is threatened by a nearly complete girdling of the trunk. Trim and remove all dead bark from the area of the wound. Use dormant scions longer than the distance to be bridged. Prepare the scions with double-beveled cuts at each end. Make an L-shaped cut in the bark of the trunk above the wound and an inverted-L directly below the wound. These will receive the ends of the scions. Several parallel scions are grafted around the trunk at 3 - 4-inch intervals. Hold the scion in its natural growing position. Insert the bottom first by raising the bark flap with the point of your knive. When firmly in place, drive a nail through the bark and scion into the wood of the trunk. Then insert the top of the scion in the same manner and anchor it with another nail. Leave a bow in the scions to compensate for trunk movement and to assure the continuing contact of cambium layers. Apply grafting compound or wax to each graft. As the name suggests, these scions bridge the wound so as eventually to unite with the trunk and continue life.

The art of grafting your own ap-ple trees can become engrossing. You can add different varieties to your backyard tree. This will increase your eating pleasure as well as stagger your harvest. You can transform the tree you have inherited from a possible liability into a sightly and productive asset.

References:

Good sources of information are always your County Agent and the Cooperative Extension Service of your state. You should also consult the Horticultural Department of your state university. The USDA also has printed information available to the homesteader.

Gardner, Victor R., *Basic Horticulture,* Macmillan Co., 1951.

Propagation of Temperate Zone Fruit Plants, (Hansen, Hartmann) Circular 471, University of California, Division of Agricultural Sciences.

Propagating Fruit Trees in New York (Way, Dennis, Gilmer), Bulletin No. 817 N.Y.S. Agricultural Experiment Station, Cornell University, Geneva, N.Y.

Budding and Grafting Fruit Trees, Extension Bulletin 508, Cooperative Extension Service, Michigan State University.

Pruning and General Care of the Backyard Apple Tree, (Langer) Information Guide No. 26, Cooperative Extension Service, University of New Hampshire.

Information Guide No. 8, Spray and Dust Schedule for Home Grown Fruit, Cooperative Extension Service, University of New Hampshire.

Drying Flowers for Winter Bouquets

TAKE TIME IN THE SUMMER AND fall to gather and dry plant material for winter bouquets. This was a popular method of bringing color into the house for the long winter months ahead in Colonial times. Today dried flower arrangements can be seen in many historic houses and restored 18th-century villages all along the eastern seaboard, for it was an art brought to this country from England where it still flourishes.

Essentially, there are three kinds of dried arrangements. Many people gather and arrange native grasses, fern fronds, interesting seed pods, and fall leaves from the roadsides and deserted meadows. These have been naturally dried and contribute tans, browns, and russet hues to the palette of bouquet material.

Some gardeners raise herbs and everlastings specifically to supply a wider range of more brilliant colors. These types of flowers are harvested at a particular stage of their development, bunched, and hung up-sidedown to air dry. They will keep their natural shape and color for

years. Everlastings include such favorites as globe amaranth *(Gromphrena)*, statice *(Statice sinuata)*, strawflowers *(Helichrysum)*, money plant *(Lunaria)*, globe thistle *(Echinops)*, Love-in-a-Mist *(Nigella)*, and the *Helipterums* — *acroclinium, ammobium,* and *sanfordii* — among others. Herb gardeners can bunch and hang old standbys like tansy and yarrow, wild marjoram, sage and chive blossoms, seed herbs (sweet cicely, dill, coriander), and the perennial favorite, lavender.

Air drying plant material is not difficult but a finished arrangement will require a good deal more stock than a fresh one does. Lacking the natural foliage and greenery of fresh flowers, the arranger will have to substitute "filler" — additional material — to fill the spaces between the stems and keep the blossoms where he wants them. Blossoms with their stems should be bunched and suspended overhead so as to allow a free circulation of air around them. The drying room should be protected from direct sunlight — which blanches colors prematurely

19

— well-ventilated, and kept slightly warmer than outdoor temperatures, particularly at night and on damp days. A drying loft or attic is excellent, but even a spare room that can be darkened and freed from normal household traffic will do. If available and safe to use, supplemental heat can be added in the drying room after harvesting everlastings and herbs to speed up the process, but care must be taken not to increase it so much that the flowers become too brittle to work with.

The real challenge in drying flowers for winter arrangements, however, is to force-dry garden blossoms that would only shrivel and fade if hung upside down. This can be done with any of several drying mediums. Force-drying will preserve both the color of outstanding blossoms *and* their natural shapes. When successfully dried and arranged, this kind of special plant material will look as though it had lately been cut from your summer garden no matter what the season.

A winter bouquet, therefore, need not be limited to stalks and pods that Nature alone has dried. It can be arranged with such flowers as peonies, larkspur and delphinium, golden marguerites and daisies, marigolds, zinnias, and roses as well as the more stable everlastings and traditional herb blossoms.

Given the proper conditions and care — protection from direct sunlight and high humidity — the arrangements will last for a year or more. Then, they will gradually fade, loose their brilliance, and eventually become monochromatic but remain interesting.

Quite different from flower *pressing,* a home art much practiced in the Victorian era, the art of flower *drying* is an ancient one. A bouquet of preserved roses was found in the tomb of an Egyptian Pharaoh. Centuries later, in India, the beauty for whom the Taj Mahal was built was also known for her ability to dry roses in sand. Whereas both of these crafts preserve flower colors, the object of force-drying flowers in a medium — rather than pressing them — is to retain their natural shapes, assuring them a third dimension.

The procedure for harvesting flowers that are to be dried differs slightly from that required for fresh flower bouquets. Fresh flowers are cut in the early morning when the dew is still on them or late in the afternoon after the heat of the day. (They can also be harvested during a slight rain to help retain the extra moisture they need.) Flowers destined for drying, however, should be cut only when it is sunny and hot — from late morning to about 3 P.M. This assures that much of the moisture will already have been drawn off by the sun, leaving a minimum amount to be extracted in the drying process. Once flowers have been cut for drying, the process — whether bunching and air-drying or using a medium to preserve individual flowers — should be initiated as soon as possible to best preserve natural color and form.

The oldest medium used for drying flowers is sand. This should be composed of fine, smooth-edged particles made free from foreign matter by rinsing and washing with

a detergent. Oolitic sand — whose granules have been coated over the centuries with layers of minerals and limestone deposits — from the great salt flats of Utah is excellent because the particles are naturally round. Don't use common beach sand or sand found in a gravel pit. Its sharp, jagged edges are likely to injure fragile petals during the drying process.

If oolitic sand is not available, you can choose from a number of other mediums.

One is a combination of two parts of sand to one part borax *or* six parts white cornmeal to one part borax. In using either of these, you may find that the borax mixture tends to mold in humid weather. In addition, some of the residue of the mixture will adhere to the blossoms and will have to be brushed away gently.

Another absorbent material is commercial cat litter, but this should be used only with the less fragile blossoms and will take longer.

The most effective and foolproof method of drying garden flowers today is to use an expensive but reusable commercial product called *silica gel*, which can be obtained from your local florist. This is a finely granular mixture in which the key crystals tell you when the moisture has been dissipated and the mixture is ready to use. The only loss year after year is caused by spillage. When the silica gel is ready to use, the key crystals will be blue; if they are not, heat the mixture in a low oven (about 150°) until the blue granules reappear. Then allow the gel to cool, and you are ready for the drying.

You should have on hand a supply of tins with lids (fruit cake tins and metal candy boxes do well), a roll of masking tape to seal the lids

A winter bouquet of force-dried flowers.

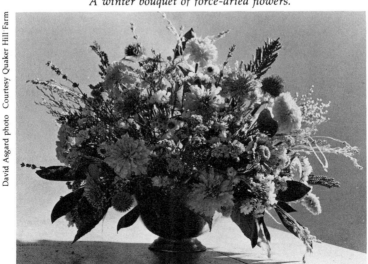

David Asgard photo Courtesy Quaker Hill Farm

while the flowers are drying, a supply of freshly harvested flowers, a pair of clippers, and a small spoon.

In all of the drying mediums you can position your flowers in one of three ways: face-up, face-down, or laterally.

To dry individual blossoms, cut the stem off about an inch below the flower head with the clippers. (Later you will have to tape a false stem to the flower using either floral wire or discarded stems of goldenrod, tansy, etc.) Do not harvest more flowers than can be arranged in the drying mixture in about 15 minutes. You should not attempt to dry flowers that have come from a florist or ones that are past their prime. Blossoms for drying must be absolutely fresh, and they should be processed as quickly as possible after cutting.

Only experience will tell you which flowers and what colors will dry most effectively. Large, fleshy blossoms (Oriental poppies, anemones, water lilies) may dry, but the petal structure is such that they will quickly reabsorb moisture when exposed to the air. Yellows and pinks are dependable colors; blues are fairly dependable but may undergo a slight color change. Reds are difficult. Unless you dry a flower that has a good percentage of orange in its makeup, the red will darken to a mahogany, nearly black. Whites, too, often present problems. They may turn a creamy, parchment-like color.

With your harvest at hand work quickly and carefully. To dry blossoms face-up or face-down, put a layer of drying medium about one inch deep in the bottom of the tin.

Flowers such as roses and peonies should be dried face-up to preserve their natural form. Place the bloom, stem down, in the mixture and allow a one-inch space all around each so it can expand while drying. Take a handful of the medium and gently trickle it around the edge of the container as far from the blossom as possible. The mixture will flow into the center slowly and cover the lower petals first. Work around each blossom in a circular way so that the level of the medium gets higher and higher. Then with a spoon, slowly sift the medium into the center of the flower, keeping the general level as uniform as possible until none of the flowers can be seen. Level the mixture by tapping the sides of the container, place the lid on it and tape around the edges to seal. It is a good idea to label the top of each container with the kind of flower and the date the process was begun. This will give you an idea of when to take it out and the approximate timing for similar flowers.

Dry daisy-type flowers face-down. You will not use as much of the mixture and more flowers can be dried at the same time. Do not, however, allow any of the petals to touch one another.

Large sprays — delphinium and larkspur, for example — which you want to keep intact should be dried laterally. If you do not have a large enough tin, make a temporary container with heavy duty aluminum foil. Proceed as you would in drying flowers face-up.

If you must move your containers after they have been filled, do it

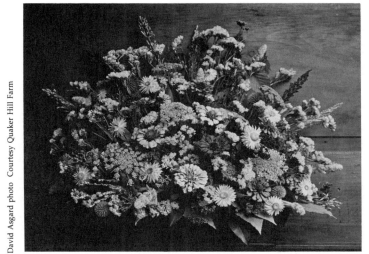

". . . a reminder of summer that will last all winter."

gingerly. Flowers can become distorted at this stage by any jiggling.

How long will it take flowers to dry? This knowledge will come by trial and error. If you keep accurate records on the tops of the lids or in a notebook, you will gain experience quickly. Generally, if using silica gel, larkspur will take about 4 days, daisy-types 3 to 4 days, large compact marigolds at least a week or longer. To check their progress, uncover the tin after several days, gently locate and lift out one of the blossoms. If dry, the petals will feel papery and stiff. If left too long, they will shatter. (If you have a particularly fine specimen that you cannot do without, these petals can be glued on again.) If the flower is not dry, gently replace it, seal the tin and wait a few more days.

Even if the blossoms are dry, it is a good idea to uncover them and let them sit on top of the mixture for a few more days. Never uncover newly dried blossoms on humid days; like sponges, they will reabsorb any moisture that is in the air.

Because flowers must be dried while the garden is in bloom, you will have to store your successes until you are ready to make a bouquet for winter. Use a wide-mouthed glass jar with a screw-on lid. First, sprinkle a few spoonsful of the drying mixture in the bottom of the jar. Then place the blossoms in layers separated by balls of tissue paper. Store in a dry, dark place.

There may be several causes of failure in drying garden flowers. The foremost will be the lack of patience and care during the drying process. Another will be from having harvested your blossoms at the wrong time or under too humid conditions. This can only be corrected with experience. Finally, failure may be caused by selecting varieties of flowers that do not dry successfully.

But given success, you will be able to fill your house with a reminder of summer that will last all winter.

Gretchen Poisson photo

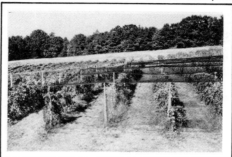

Designing and Building a Grape Arbor

GRAPES ARE AMONG THE MOST widely grown small fruits in the world. Their vines must be supported to enable them to produce successfully, but an old-fashioned grape arbor will enhance your property by becoming part of your permanent landscape design.

The majority of commercial grapes for table and wine are trained on long, parallel post-and-wire trellises, but the home-designed arbor can be imaginatively tailored to fit any site — however small — and will serve as an outdoor bower of dappled shade or as a passageway between buildings to protect you from the summer rain. Your arbor can be built to roof a terrace adjoining the house or located at a distance, overlooking the garden. It can divide your grounds or screen unsightly places from view. Finally, the arbor will enable the homeowner to limit vine growth through annual pruning and to reach his harvest conveniently in the fall.

If you select a proper site and choose varieties of grapes adapted to your climate and locale, there is little reason your home vineyard — given some regular maintenance — should not last a lifetime or two. The average commercial planting in this country lasts from 25 to 50 years before it is thought to be uneconomical. The vineyard you plant for home use should still be going 75 years from now.

There are three general types of grape: the *North American* varieties (the most fruity tasting and winter hardy for northern climates, with skins that slip from the pulp easily and are not eaten); the *European* or *Old World* (best known for winemaking with the highest quality fruit but the least hardy vines, their skins adhere to the pulp and can be eaten); the *hybrid grapes* (European varieties grafted to North American stock, they combine characteristics of both parent plants in varying degrees).

The varieties you choose to plant may not be as important as the attention given to selecting a site — proper water and air drainage are the principal considerations. Grapes thrive on sloping land with a southern or western exposure near large bodies of water. They require a long growing season and hot weather if they are going to ripen well before frost. However, they will produce under a variety of conditions provided the site is well drained. Ideally, they should be planted in a light loam which contains a substantial amount of organic matter and is underlaid with porous subsoil. The texture of the soil should not be so light as to encourage too rapid drying out. The fertility of the soil is not as crucial as its structure.

Air drainage is equally important. Although grapes are among the last of the small fruits to leaf out, the site you choose should be somewhat elevated so that cold air, which is heavier and tends to settle in low areas, will drain off in the spring and fall. Good air circulation during damp summer periods will also help discourage the spread of disease.

Commercial growers usually do not build trellises until the second year after an early spring planting, and then they use galvanized No. 9 or No. 10 gauge wire as support strung between six-foot-tall posts spaced up to 24 feet apart. However, the home gardener should erect his arbor the first season before the vines and their root systems have a chance to get in the way of construction. Traditionally, wood has been used for arbor building but metal will last longer.

Wooden posts — 5 inches to 8 inches in diameter — were commonly cedar, oak, chestnut, or locust. Untreated, these will last from 10 to 15 years. If painted with a wood preservative or pressure treated, their useful life can be extended considerably. Another way to extend the life of the arbor and make it more stable is to sink the butt ends of the posts in two feet of concrete (five parts sand and rubble, one part cement) that is twice the diameter of the post. Notch both sides of the base with an ax to allow the concrete to hold the post firmly. To provide headroom and allow for the sunken portion, posts should be between 8 feet and 10 feet long.

FOUR TYPES OF GRAPE ARBOR

The Lean-to (see p. 26)

This kind of arbor can be attached to the southern or western side of a building and will provide shade for eating and relaxing. With one side occupied by building you will need to plant only the other three with vines, spaced not closer than eight feet apart. There will be little chance the foliage will block early spring sunlight from the windows because grape vines are late in leafing out. The thick shade the vines will provide in the summer, however, will help keep the house cool. Use finished lumber or rough-cut posts and rafters from a local sawmill depending on your taste and your budget. Attach rafters to the building at right angles to the wall and nail 1" x 3" strapping in lines on top of the rafters parallel to the eaves. (Remember to use galvanized nails

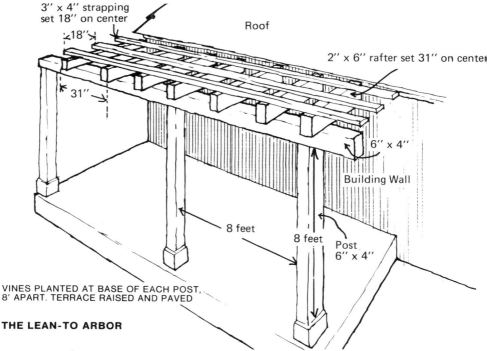

3" x 4" strapping set 18" on center

Roof

18"

2" x 6" rafter set 31" on center

31"

6" x 4"

Building Wall

8 feet

8 feet

Post 6" x 4"

VINES PLANTED AT BASE OF EACH POST, 8' APART. TERRACE RAISED AND PAVED

THE LEAN-TO ARBOR

throughout.) The finished arbor can be made less rustic by shaping the terminals of each rafter and applying molding to the base and capital of each post. Set vines along the outside, eight feet apart. When they reach the rafters, space out lateral branches on both sides and tie them to the strapping until they establish themselves.

It should be mentioned that one disadvantage in having an arbor adjoining the house is that ripening grapes can litter the terrace and attract yellow jackets in the fall.

The Free-Standing Arbor

Located anywhere on your property, this arbor can be designed to fit the site where drainage conditions are right. Effective arbors can be constructed above a retaining wall overlooking the garden and will serve both as a focal point and a leafy outdoor room. Determine the floor plan by its location and make

allowances for principal walkways. Plant vines on all sides of the arbor but train them so access is convenient. The area under the arbor should be leveled. The floor can be covered with cut gravel or paved with brick set in sand, slate, flat field stones, or rounds of wood that have been treated with a preservative.

The Arbor Passageway

Built as a walkway between two buildings such as the house and garage or shed, this tunnel arbor will provide cover during light rainstorms and help make the homestead appear more like a single unit. It is constructed by setting two rows of parallel posts eight feet apart in the rows, and the rows far enough from each other to make a convenient walkway. The vines are trained across the top to form a roof. Given the space, all sorts of variations can be attempted: a central area can be widened to house

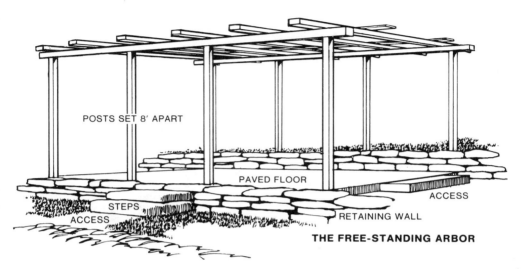

POSTS SET 8' APART

PAVED FLOOR

ACCESS

STEPS

ACCESS

RETAINING WALL

THE FREE-STANDING ARBOR

benches and a table, or crosswalks planned along the length of the arbor to allow easy access to other sections of the grounds.

The Arbor Screen (see p. 28)

The straight line trellis can be extended to any desired length. Grape foliage can be used as an effective screen in the summer, or the arbor can simply be used as an outdoor divider — separating lawn from cultivated gardens, for example. While not providing overhead protection, the trellis will cut down the force of the wind but still allow for air circulation. It can be constructed with wooden or metal posts set up to 24 feet apart. Three posts will be needed to support six vines. String galvanized wire between the posts in two parallel rows — the lower one 3 feet to 3½ feet and the upper one 5½ feet to 6 feet from the ground. A higher trellis would thwart efficient harvesting. If you prefer all-wood construction, set your posts at 8-foot intervals and nail on parallel 1" x 3" strips for horizontal support. The end posts should be braced to counter the weight of the vines and set deeper in the ground than interior posts. For an espaliered look and high production, train the vines in any one of the common commercial methods.

TRAINING AND PRUNING

Once the arbor has been built and the vines are growing, you will have to maintain them. Training regulates the growth of the vines; pruning regulates the crop, and usually both are done in a single operation. The commercial producer may use any of several methods of training (the Four-Arm Kniffen is common for most American varieties, the Hudson Valley for French hybrids, the Umbrella Kniffen for long-caned vines, the Keuka Renewal for large-

27

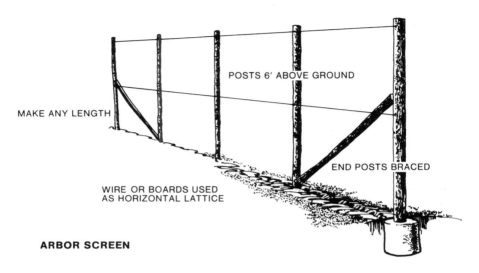

MAKE ANY LENGTH

POSTS 6' ABOVE GROUND

END POSTS BRACED

WIRE OR BOARDS USED
AS HORIZONTAL LATTICE

ARBOR SCREEN

clustered, upright growing varieties) which often are too technical for the home-use gardener who builds his arbor.

The first objective of the home gardener should be to establish strong-rooted plants and train the trunk vertically to reach the top of the arbor. Thereafter, annual pruning should aim to keep lateral growth evenly distributed and renewed each year so that the vines will be productive and can be systematically managed. Hardy American varieties can be pruned after the leaves drop in the fall but before the vines have frozen. However, maintenance can be delayed until spring even though the vines then may "bleed," exuding sap from the cuts.

For arbor vineyards, the trunks of the vines must be longer than for those grown on screen-type trellises. No pruning should be done the first season after the vines are set out. The following spring remove all shoots except those that are the strongest. Cut these back to two buds each. Tie the main trunk with heavy string in a nearly vertical position from just below the terminal buds to the top of the arbor, train lateral growth to fill in where you want it and keep this in place with narrow bands of torn cloth or string; do not tie too tightly. Practice clean culture around the vines.

VARIETIES TO PLANT

In choosing what grapes to plant, keep in mind your climate and your objectives. For those living in central and northern New England where winter temperatures fall to -25°F. or lower, the American varieties will be the most dependable. Of these the Concord (developed 1843 in Massachusetts from a native seed) is still the grape

most widely grown east of the Rocky Mountains. This is a late, blue-black, hardy grape. Others of the same color but with a slightly different growing season and size are the Fredonia, Van Buren, and Buffalo. The leading white variety for this climate is the Niagara, and if you want to complete the tri-color scheme plant the Delaware. A perusal of any nursery catalogue will introduce you to the names and characteristics of other significant varieties that might be suitable to your situation and taste. Consult your county agricultural agent and the horticultural department of your state university as well.

Once your arbor is constructed and the vines thriving you will be rewarded with shade in the summer and a bumper crop in the fall. Grapes are ready to pick when their color is perfect, flavor and aroma are high, and the berries beginning to soften. The stems will have changed from green to brown and the seeds will be dark. Even a small arbor should produce enough fruit to supply your table for desserts, for making fresh grape juice and jellies and, with some experimentation and practice, the material and incentive to make wine at home — one of the obvious benefits of the grape that has been praised for thousands of years.

References

Many books and pamphlets have been written on the cultural techniques of growing grapes. Some will be more exhaustive than you need.

The first step is to consult your County Agent who will know local grape-growing conditions and be able to recommend specific varieties for your area. After this write to the horticultural department of your state university.

Here are some publications you may find useful:

Shoemaker, James S. *Small-Fruit Culture*, Blakiston Co., Philadelphia, Pa.

McGrew, J.R. "Basic Guide to Pruning," American Wine Soc., 1973.

Latimer, L.P. "Growing Grapes in New Hampshire" Revision of Extension Circular No. 173, UNH, Durham, N.H.

Cooperative Extension Service Information Guides from your state university on cultural techniques and spray and dust schedules.

Annual catalogues from fruit specialists such as Miller's (Canandaigua, N.Y.), Stark Bros. (Louisiana, Mo.), Kelly Bros. (Dansville, N.Y.).

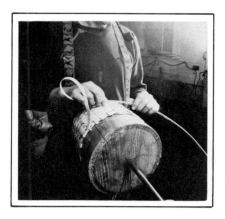

Weaving Baskets with Black Ash

Photos by David Asgard

USING HIS GRANDFATHER'S TOOLS, wooden forms, and methods, Chet Colburn, Jr., of Weare, New Hampshire, has resurrected the family craft of making baskets with strips of black ash.

There are as many kinds of woven baskets as there are materials and uses. Colburn's father and grandfather, who had been general farmers in southern New Hampshire, specialized in making bushel baskets with handles for carrying or storing apples and potatoes. They also made peck measures, egg baskets, and experimented with a variety of shapes and designs, many of which still hang on display from the beams in the younger Colburn's house.

According to Colburn's father, who has been helping his son reconstruct the family craft which he learned from *his* father as a boy, they produced about a hundred bushel baskets and several other containers during a winter season.

What makes the Colburn baskets distinctive is that they have a concave base to give the basket stability when it is set on a level surface. Otherwise, loaded either with heavy farm produce or fragile eggs, the basket would have a tendency to tip and spew out its contents.

The baskets are all made from black ash. Locally sometimes called brown or marsh ash, *Fraxinus nigra* is one of the more valuable but elusive members of the prolific ash

30

family. Because this wood splits evenly and bends without losing strength, it has traditionally been used for making baskets, chair bottoms, and barrel hoops. After the leaves have fallen the tree is sometimes confused with a young elm. However, this ash is a slow-growing, slender tree that prefers swampy areas and often flourishes in standing water.

In the fall Colburn locates an ash 8-10 inches in diameter. He peels the tree green. Using a lightweight mallet to pound the log with one hand while lifting the peel with the other, he works down the entire length of the log. It is relatively easy to peel off the soft brown wood in annual layers, like lifting off thin sheets of veneer. Ideally, the wider the peel, the better the result. In bigger trees the grain will be thicker and the splits more workable. There is some evidence — both in the memory of the senior Colburn and the width of the grandfather's stripping device — that black ash used to grow larger than it does today.

After peeling the tree, Colburn rolls and bundles the strips and leaves them in a corner of the workshop to dry. Fresh peels will shrink and retain a raw, new look. Just before he starts weaving, Colburn soaks the dried strips in water to make them pliable.

The basic steps in making a basket have not changed over the years. Only the simplest tools are necessary. First, you must split, or "strip," the peels into uniform widths, then weave a base and sides, and finally finish off the rim to give it strength.

To strip the peels, Colburn pulls them through a simple device his grandfather used: essentially, it is a wooden box in the top of which are embedded a row of razor blades at 1-inch intervals. The box is about 6 inches across but could be made to any dimension.

To form the base of the basket, Colburn uses his grandfather's base mold or form. This is a low conical, turned-wood block which is used to form a concave base. At the apex he has sunk a nail on which to impale the staves. He crisscrosses 8 to 10 strips on this point so they radiate outwards for nearly equal lengths and even distances. Now he presses a metal ring down where the staves cross, places a small wooden block on top of this, and lowers a hinged brace from the ceiling. A threaded bolt has been sunk into the end of the brace. When this is turned, pressure is applied so this simple vise holds the staves in place at the point where they intersect. Before beginning to weave, Colburn splits one of the staves in half from the central point to the end. This results in an uneven number of staves which can be alternated as he weaves the base.

The weaving is done by going over and under adjacent staves with a narrower rod or split.* Working from left to right around the base, when one split is exhausted, he lets in another and continues weaving.

*The *staves* in basket weaving are stationary, like the warp in loom weaving (see photo no. 4 on page 32); the *rod* (or *split*) in basket weaving is like the weft or woof in loom weaving. These are the pieces that are woven in and out of the staves. When one rod is used up, another is let in.

31

When he reaches the diameter of the proposed base (about 9 inches for a peck measure), the vise is released, the basket base removed, and Colburn is ready for the next step.

Many basket makers do not use a mold, but the Colburn method of making a basket around a solid, wooden form helps assure a uniform, even-sided product. The woven base is reversed now and set evenly on the concave end of the mold. He anchors the staves near their center point with nails driven through small squares of iron and into the form. Then Colburn drops a metal hoop over the radiating stave ends to keep them close to the sides of the mold. He inserts a metal bar into a hole in the opposite end of the

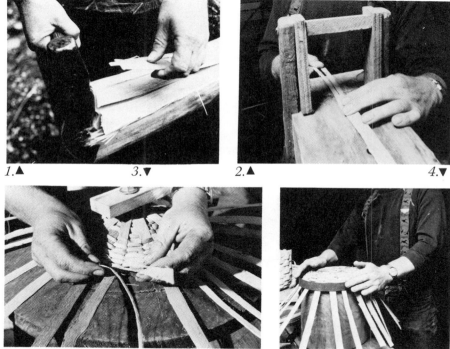

1.▲ 3.▼ 2.▲ 4.▼

1. *After loosening the wood with a mallet, Colburn lifts off the peel in annual layers.* **2.** *He strips the peel with a device having a row of razor blades embedded in the top at one-inch intervals.* **3.** *The base is woven on a low conical block.* **4.** *The woven base is then reversed and set on the concave end of the basket mold. A metal hoop keeps the stave ends close to the mold.* **5.** *A metal bar inserted into one end of the mold is clamped in a bench vise. This allows Colburn to rotate the mold at an adjustable angle.* **6.** *Shaving a wood strip for a single-handle basket.*

mold and clamps this in a bench vise. This allows him to rotate the mold against his chest at an adjustable angle as he weaves.

Colburn weaves the sides with uniform-width splits (about ½ inch). When each is exhausted, he lets in another until the sides are about 7 inches tall.

Now the basket is slipped off the mold. Colburn has found that the more closely woven his basket is, the more difficult it is to remove from the mold. Sometimes he has to resoak it — mold and all — before the basket can be detached.

The ends of the staves must be trimmed and a rim made to finish off the basket and give it stability. Colburn does this by inserting one ring of black ash around the inside top circumference, another on the outside, and binding them to the stave ends with narrow strips plaited at even intervals.

Handles for the baskets can either be twin arcs opposite one another, or a single handle made from white ash or oak that arcs across the top of the basket. To make the double handles Colburn soaks wide strips, inserts the shanks down through the rim and the horizonal woven strips, and bends up the ends to anchor the handles securely.

To make a single handle is more complicated. The wood of the desired dimension is steamed or boiled, then bent and anchored over a rack until it is dry. The ends of the handles are notched, tapered, and forced down into the weaving. The notches keep the handle from slipping out when the loaded basket is carried.

Colburn's finished baskets are made entirely of wood, with no nails or staples. Their shape and the use of native material has been dictated by examples of baskets made by his father and grandfather in the same building. Colburn plans to continue the family craft.

"But there may be one hitch," he says. "That's the difficulty of finding a supply of black ash around here. With these small diameter trees, it takes an awful lot of pounding to work up a good supply of strips."

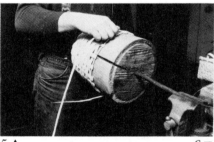

5.▲ 6.▼

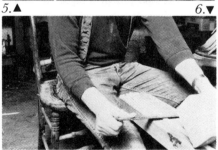

ↀↂↀ

33

Sharpening and Rehandling Hand Tools

KEEPING KNIVES AND OTHER COM-mon hand tools in prime cutting condition is the mark of a careful craftsman. Sharp tools make all jobs easier and faster. Whereas kitchen knives and woodworking tools de-mand constant attention throughout the year, the care given others — axes, hatchets, and garden tools such as spades, edgers, hoes, etc. — is more seasonal. Winter is a good time to plan for the gardening season.

With only a minimum investment in files or bench stones, many hand tools can be salvaged and recondi-tioned. Often these tools — if they have been handed down from father to son — are of better quality than similar ones manufactured today.

The homesteader is fortunate to have a wide choice of sharpening devices on the market, ranging from the simplest hand-held mill files and synthetic bench stones to the most expensive motor-driven grinding wheels. It is handy to have an electric grinder in your workshop because it will do the job more quickly, but most home sharpening can be done satisfactorily with less expensive equipment. Also, hand sharpeners have the added advan-tage of being portable.

When sharpening any tool there are several points to keep in mind:

the original bevel (angle of the cutting edge) must be maintained, no more metal should be removed than is absolutely necessary to gain a sharp edge, and — if using an electric grindstone — the blade should be kept cool by dunking it in water frequently so as not to draw out the temper of the metal.

The bevel angle is formed by grinding away the sides of the blade to form a wedge, and this angle varies with each kind of hand tool. Often — with wood chisels, plane irons, scissors, hoes, etc. — the blade is beveled on one side only. Other tools such as knives and axes are beveled on both sides of their blades. The more acutely an edge is beveled, the more brittle it becomes. This means the edge will break down more frequently and have to be resharpened. Presumably — although you may purchase a new tool that is not as sharp as it should be — the manufacturer has ground the proper cutting angles for the job each tool will be expected to do.

The reason for not filing off more metal than necessary is twofold: too much grinding beyond that needed to establish a fine edge will reduce the life expectancy of the tool; and often, as with kitchen knives that are used regularly for precise work, the metal immediately behind the cutting edge is needed to support and strengthen it.

Before doing any sharpening, note the original angle of the cutting edge so you will be able to duplicate it — and at the same time look for any nicks in the blade. Since these will not cut, you should file or grind the blade beyond the deepest of these notches in order to establish a uniform, fine edge.

Microscopically, the sharpest blades are composed of a series of uneven, ragged planes. These allow the edge to take hold of the material being cut. A dull tool will feel smooth to the touch. Therefore, to test for sharpness — both before you begin and to tell you when to stop — feel the cutting edge with your thumb, applying only light pressure as you move it *across* the blade. If it catches at your skin, presumably it is sharp. A second method is to lightly shave the back of your hand with the blade. Finally, hold the cutting edge up to the light and squint along it as you gently rock it back and forth. A dull edge will reflect light and appear as a shiny, narrow surface, while a sharp edge will be invisible.

Different bevels produce different types of edges. Left: concave bevel, hollow-ground edge. Center: convex bevel, cannel-ground edge. Right: flat bevel.

If you are hand-sharpening tools that are not particularly hard metal (axes, hatchets, garden hoes, shovels, etc.) buy a 10-inch bastard mill file. For finer work add a second-cut mill file and even a smooth mill file to your collection.

For harder metals that require

even finer edges there are hand and bench stones — both natural and synthetic — which will last a long time if cared for properly. These come in various grits from coarse to extra fine. You can also purchase a silicon carbide stone which has a medium grit on one side and fine on the other. All stones should be used with a lubricant — a light household oil, mineral or kerosene, or as a last resort, water — which floats away metal particles and prevents the pores of the stone from becoming clogged and ineffective. To clean a stone, place it in a pan and warm it in the oven or over a fire. Then wash it with gasoline or kerosene (not near an open flame!). Keep all sharpening stones covered when not in use to protect them from dirt and grime.

Other hand sharpeners include the traditional chef's steel or an abrasive cloth or paper tacked to a small wooden paddle. Hand- or foot-operated grindstones which once graced the dooryards of most farms can still be found at auctions and flea markets, but all too often the stones are so deteriorated that the grindstones are useless to the craftsman.

Modern professional bench grinders are driven by ½ hp motors. Be prepared to spend as much as $145 for a ball-bearing model with two stones and eye shields. Otherwise, salvage an unused home appliance electric motor from an old washing machine or dryer and convert it into a suitable bench grinder. You will be spending considerably less. If you have or intend to purchase a bench grinder, you might do well to investigate the new vitrified aluminum oxide grinding wheels. These man-made stones cut faster and cooler than the traditional carborundum grindstones, eliminating some of the danger of changing the temper of a cutting edge during the sharpening process.

Of course, there are combination can openers and grinders in most discount stores today. The knife-sharpener side is equipped with metal guides so you can recreate the original bevel of the blades.

If you prefer the ease and power of electricity but do not own any of these devices, you can buy an abrasive disc or mounted grinding wheel for your portable electric drill. However, the results of sharpening with a hand-held drill will be disappointing, for there is too much play while the grinder spins. More uniformly sharp edges can be obtained either by filing or grinding and then finishing off on a stone.

Here are some practical hints about sharpening a few of the more common hand tools.

KNIVES

Knife blades can be hollow-ground on a wheel. This produces a concave bevel with a radius equal to that of the wheel, and allows a finer cutting edge to be fashioned on a whetstone as a follow-up. If ground on the side of a wheel or on a bench stone, the bevel will be flat. Heavy-duty edges are shaped with convex bevels. The usual method of sharpening knives which are not badly nicked is to use a medium abrasive first and follow this with a fine grit oilstone. For the extra fine edge

which you require on a boning knife, for example, strop the cutting edge on a piece of smooth leather.

Whetting a knife blade on an oilstone should be done with the cutting edge of the blade *leading* as you stroke elliptically across the stone. When stropping a blade, the cutting edge should be *trailing* the stroke.

Sharpening blades will often produce a jagged roll of thin metal along the cutting edge. This is called a feather edge, wire edge, or burr. If it cannot be seen, at least it can be felt when you pull the blade lightly across the back of your hand or a piece of fabric. This is one signal to stop sharpening because it means the edge is thin to the point of perfection. To remove the burr, whet the blade on a fine stone.

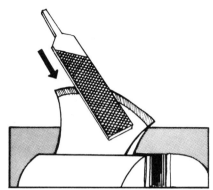

To sharpen an ax, clamp the head in a bench vise and file with a mill file in the direction and at the angle shown by the arrow.

AXES AND HATCHETS

These seem particularly susceptible to nicking unless one is a superlative woodsman. Unlike chisels, they are angled on both sides of the blade. After grinding or filing away imperfections, whet the blade (in circular movements if using a hand stone, or in long strokes at an angle if using a file). The blade of a chopping ax should be filed somewhat thinner than one used for splitting wood.

GARDEN TOOLS

It is remarkable how much easier garden work can become with a sharpened hoe, spade, or edger. Insert the tool in a bench vise and file with long strokes across the upper side of the cutting edge. Hoes can also be sharpened on the sides of their blades as well, which will allow the gardener to nip off weeds in less accessible places. Touch-up filing can also be done on hedge clippers, pruning hooks, rotary lawn-mower blades (remember it is

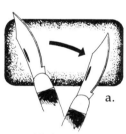

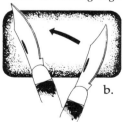

a. *Whetting a blade — the stroke is made with the cutting edge* leading. b. *Stropping a blade — with the cutting edge* trailing.

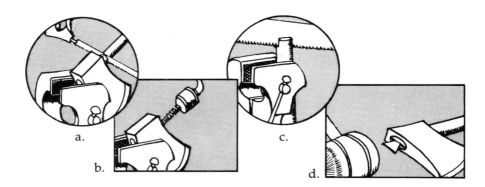

Rehandling an ax. a. *Saw off old handle;* b. *drill out the hole in the ax-head.* c. *cut kerf, or slot in new handle;* d. *insert new handle into head and pound wedge into the kerf. Lastly, saw off wedge and handle even with ax-head.*

very important to keep the two sides of a rotary mower blade evenly balanced, to avoid excessive vibration when running), shovels and other hand tools used around the garden and fields.

REPAIRING AND REPLACING HANDLES

Too many serviceable tools are thrown away when their handles break. New handles can be shaped at home by the careful workman who knows the properties of wood, or replacement handles are readily available at lumber and hardware stores and can be made to fit all varieties of common tools.

To replace a broken or split handle, you must first remove it. Clamp the tool in a bench vise and with a hacksaw saw off the handle even with the head. Remove the remaining wood from the eye of the tool by first drilling a series of holes and then forcing the pieces out with a hammer and punch. Work the replacement handle down to a proper fit with a rasp, trying it in the eye of the tool frequently. If using a wooden wedge to fix the handle in place, be sure the kerf (a slit in the end of the handle) is cut so that it extends more than halfway down the head of the tool when the handle is in place. This is not necessary when using a metal wedge. Drive the new handle into place with a mallet by either striking the metal head or hitting the base of the handle. When the handle is properly seated, drive in the wedge. Saw off the protruding head of the handle so that it is flush with the top of the tool.

Most craftsmen recognize individual idiosyncrasies with regard to the proper angle one should

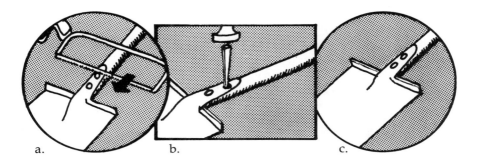

Rehandling a spade. a. Saw off rivet heads in old handle; b. punch out rivets; c. insert new handle. Then drill holes for rivets in new handle; insert rivets and hammer down the rivet heads.

maintain between the head and handle of such tools as axes and hammers. When you find a particular hammer, for instance, that feels especially comfortable to use — they are *not* all the same — make a pattern of the relationship between the head and handle. Should you ever break the handle, this pattern would be most useful. In the absence of any pattern, a general rule is that when the face of the hammerhead is resting on a flat surface, the end of the handle should just touch the surface as well.

Many shovel and spade handles are riveted. To replace these, the rivet heads must be ground or filed down and the rivets punched out. Remove the remainder of the broken wooden handle by drilling and punching, fit the replacement, and bore holes that will line up with those in the shovel shank. Insert the new handle and rivet it in place, using a ball-peen hammer.

Keeping tools sharp is a continuous process, and it is a necessary chore that can be perfected only by experience. But a really fine-edged tool will make any cutting job in woodlot or kitchen easier, quicker, and more pleasant.

References

Jones, M.M. *Shopwork on the Farm,* McGraw-Hill Book Co., 1945.

Walton, Harry, *Home and Workshop Guide to Sharpening,* Popular Science Publishing Co., Harper & Row, 1967, Revised 1973.

Weygers, A.G. *The Making of Tools,* Van Nostrand Reinhold Co., 1973.

Painting Colonial Patterned Floors

Stephen T. Whitney photo

Wooden floors painted with bold geometric designs were common in Colonial America during the 1700s. Although evidence of original painted floors is hard to find today — unlike early stenciled walls and painted furniture, floors were subject to constant wear and have often been painted over, sanded down, or covered up — art historians can point to a few early American portraits and some family and business journals to confirm the popularity of this kind of home decoration.

Actually, floor patterns have been designed and executed for thousands of years. For centuries geometric designs executed in mosaic, marble, quarry or ceramic tile, parquet, or any of the range of contemporary composition tiles, have added interest and color to floors in both domestic and public buildings.

When most people could not afford the luxury and comfort of imported rugs and carpets, painting patterns on wooden floors was one way to use native materials and copy fashion trends. Previously, home floor decoration was coupled with sanitation. Because raw wooden floors had to be scrubbed regularly, the earliest settlers used clean sand and a stiff broom fre-

quently. In the best room of the house they often left a sprinkling of sand on the floor, working the sand into a pattern with their broom or a feather.

Whether executed by an itinerant craftsman or by the homemaker, a design painted on the floor was more permanent than sand, and could be done quickly by anyone who could handle a brush and use a measuring stick. It afforded the designer a chance for personal expression and was an inexpensive way to liven up a room.

Today, patterned floors can still mask patched or imperfect flooring in an old house or can be designed to simulate wide floorboards where none exist. And, of course, it is an authentic way to imitate Colonial decoration.

David and Gerard Wiggins of Sanbornton, New Hampshire, are artisan brothers who carry on many of the traditions of itinerant craftsmen from past centuries. Recently they painted two patterned floors in the home of Mr. and Mrs. Roger Quigg, owners of the Andirons Inn in West Dover, Vermont. Using oil-based floor paints and commercial brushes, a chalk line, and a double-edged chisel for scoring the patterns on the floor, the Wigginses recreated a popular home decoration that flourished in 18th-century America.

The Wigginses also travel throughout New England retouching and reproducing old wall stencil patterns*, decorating rooms with

*See *The Forgotten Arts*, Book Two, "Decorating a Wall with Old-Fashioned Stenciling," by Richard M. Bacon, p. 45, Yankee, Inc., 1975.

Opposite: *A three-color "building-block" design based on a 3,000-year-old Greek mosaic floor. See diagram, p. 44, for pattern.*

Below: *Alternating black and off-white diamonds on this parlor floor (Prentis Collection, New Hampshire Historical Society) enhance the airy space of the room.*

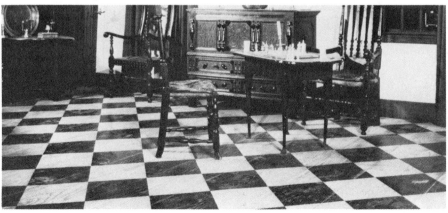

Stephen T. Whitney photo

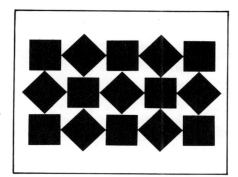
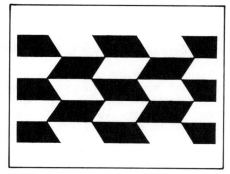

Two 18th-century floor designs from Nina Fletcher Little's booklet (see References). The left-hand design is for two or three colors, the right for two colors only.

contemporary stencils of their own design, dealing in 19th-century genre and landscape painting, and following the family tradition of restoring houses and handling early American antiques.

The design they chose for the entry hall — a building-block pattern — is perhaps 3000 years old. Executed in three colors, the pattern was copied from a mosaic floor on the Greek island of Delos. Often the same cube design — with variations in color and intricacy — can be seen in early American primitive portraits painted prior to 1800.

Squares, diamonds, and cubes were the most popular geometric forms used to decorate floors. They lent a degree of graciousness and opulence to a room. Often the designer "marbleized" or veined the paint while wet to enhance the illusion of a tile floor.

Usually floor patterns were carried to the baseboards; but in the Quiggs' dining room the decorator wanted a wide border left around

the checkerboard design, to suggest the placement of a carpet in the center of the room.

The same type of design was used by another floor painter in the reconstructed and furnished parlor of the Prentis Collection at the New Hampshire Historical Society in Concord. There, the squares were slightly extended to form diamonds which preserve the perspective over a large expanse (approximately 22 feet long by 17 feet wide) and make it appear even larger.

The patterned floors in the two rooms, although similar in conception, produce different effects.

David Wiggins' checkerboard design is made up of 15½-inch alternating brown and off-white squares. After establishing the size of the square in relation to the width of the floorboards, he and his brother snapped a chalk line to make diagonal parallel lines 15½ inches apart. Next, they did the same at right angles to these.

"One of the problems in the plan-

ning stage is to center the design in the room," Wiggins says. "This means a lot of measuring beforehand."

Once the pattern of alternating squares had been chalked, they scribed the design onto the floor with the double-edged chisel. This was drawn along the chalked lines but was not allowed to gouge and splinter the pine.

"Scribing helps you paint truer edges," Wiggins explained. This was the Colonial method of keeping the paint in one square from running over onto another.

The Wigginses laid out the pattern on untreated pine boards. They gave each square two coats of paint and suggested the owners use it for several weeks before sealing the floor with two coats of polyurethane. Normal wear will take away the newness of a painted floor and tone it down to fit with its surroundings.

The floor in the New Hampshire Historical Society is painted on matched oak boards more than a foot wide. The pattern was painted in diamonds of black and off-white that measure 19¼ inches by 17½ inches from point to point. Each side of the pattern is 13 inches long. The paint was rubbed with the grain before it dried to bring out the texture of the oak floor. Then it was sealed. In this room the pattern runs to the baseboard on all sides and ends in half-diamonds along the perimeter.

More challenging to lay out, to paint, and to look at is the optical illusion created by the three intersecting lines of the block pattern which the Wigginses used in the entry of the Vermont house. Scribing the floor was not possible because a continuous line would have overrun many of the geometric elements in the pattern. It was established instead with pencil on bare wood.

First, David Wiggins measured the width of the uniform floorboards and divided this by four. He took this measurement to run lines parallel to the joints between the boards from one end of the entry to the other, dividing each floorboard into four equal strips. Next, using the same measurement, he ran parallel lines at right angles to those already marked. This formed a grid of squares. Finally he drew parallel *diagonal* lines in one direction only which bisected each square.

The pattern is composed of squares and rhomboids — geometric figures whose angles are oblique and adjacent sides unequal. Unable to scribe the floor, Wiggins used short pieces of masking tape to keep the three paints where they belonged as he painted.

There are certain disadvantages to painted floors, whether patterned or plain. First, they must be retouched every few years if traffic over them is heavy. Second, elderly people may find sealed and polished painted floors dangerously slippery, and the patterns may prove confusing to persons with poor eyesight. Then, too, rooms without rugs generally have poor acoustics and tend to be drafty in cold weather.

Toward the end of the 18th century, this type of painted floor began to lose its appeal, and for a time stenciling was used to accomplish

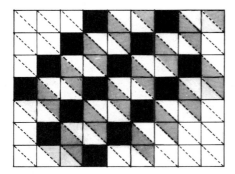

Layout for the building-block pattern shown on p. 40 — a gridwork of squares, with each square bisected by a diagonal.

the job more quickly. Then floor cloths with painted overall designs were imported from Europe (costing far less than woven carpets) and they soon became popular. These cloths were successful in cutting down drafts, establishing more permanent designs, and adding purchase for the feet.

In the first decades of the young nation taxes were levied against foreign imports to stimulate native industry. Soon Yankees were manufacturing not only their own floor cloths — heavy woven material that had been stiffened with sizing and patterned with paint — but rugs and carpets as well.

What many consider the most authentic Colonial treatment of painted floors is the splatter paint method. Drops of different colored paints are sprinkled on a dried uniform background. According to historians, however, this method of floor decoration — first used on Cape Cod — was not found before the 1840s.

When patterned painted floors first became the vogue in this country is a question people like John F. Page, director of the New Hampshire Historical Society, hesitate to answer. Even the visual evidence of early portraits can be questioned as reliable sources. According to Mr. Page, one does not know whether the artist was recording an actual setting or was using his decorative talents to embellish the painting and make it more salable.

As affluence increased, fashions in floor treatment changed. But for a brief period in Colonial America painted patterns on wooden floors decorated many homemakers' best rooms — from urban centers to outlying farmhouses.

References:

Nina Fletcher Little: *Floor Coverings in New England Before 1850.* Old Sturbridge Village Booklet Series, 1967.

The Prentis Collection, New Hampshire Historical Society, Concord, N.H.

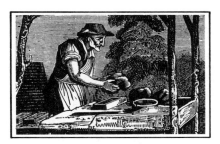

Making and Firing
Durable Weatherproof Bricks

From the earliest times man has fashioned clay into regular shapes and sun-dried them to provide building material for adobe houses in regions where temperatures are high and no other suitable material — stone or wood — is available. But these sun-dried bricks will not hold up if exposed to northern winters. The manufacture of a durable, weatherproof brick requires that the sun-dried brick be fired in a kiln.

From April to October while the weather held, the manufacture of bricks on the homestead was a seasonal occupation of many New Englanders in the late 18th and early 19th centuries. These bricks were used to construct safer chimneys and more permanent buildings in a new land.

Colonial bricks — still found today in abandoned cellar holes — are thin, multi-colored, irregular in dimension, and often warped. However, they are avidly sought for use in authentic restoration projects and command a handsome price, frequently as much as 25¢ a brick.

The ingredients necessary for brick-making haven't changed since ancient times: clay, sand, and water — all of which are still abundant in rural New England. If you wish to make your own bricks today, be prepared for hard work, and have on hand an ample supply of dry cordwood, cut into four-foot lengths and split.

Clay underlies much of New England, deposited in layers beneath the topsoil. Often areas of poor drainage indicate the presence of clay just below the surface, because the clay layer retards the percolation of water downwards. Clay layers can also be seen as blue, gray, or yellow strata where the earth has been excavated, or along river banks.

To begin making bricks, dig an ample supply of clay and mix about one part of sand to every two parts of clay. According to David Goodrich, one of the great-grandsons of the founder of the W.S. Goodrich Brick Works in Epping, New Hampshire, sand controls shrinkage

45

as the brick dries, and does not affect the porosity of the finished product. Be forewarned that unless it is mixed with other kinds of clay, New England's native blue clay produces a brick that is too dense, too brittle, and prone to shrinkage.

In the brickworks of the 1600s, clay, water, and sand were mixed until the ingredients flowed smoothly through a hole in the mixing form. Then it was allowed to settle, the water poured off, and the clay scored in the desired sizes — like marking off fudge in a mammoth pan — and left to dry. Finally, the bricks were fired.

Timothy Pickering, American Revolutionary War general and statesman, wrote to Noah Webster in 1792 and described the preliminary brick-making process of that period:

> Molds must be shod with iron, each mold made for a single brick. These are thrown into a tub of fine, sifted sand — not water — to prevent the bricks from sticking to the sides. To make 2000 bricks a day requires one molder, one man to work the clay, one man to wheel it to the tables, and a boy who bears off a single brick at a time.

Later it was found the composite molds were more efficient, even though they were heavier. These can be constructed of 5/8-inch stock to form six bricks at a time (see diagram, p. 50). The cross braces are rabbeted or dovetailed into the side rails, and the top and bottom edges of the perimeter are reinforced with iron strapping to prolong the useful life of the mold. Handles can be affixed to each end of the open mold to help the brickmaker lift the form from newly-made bricks.

Before you begin to construct your mold, determine the dimensions of the finished brick you want to work with. When clay dries and is fired, it will shrink overall by about 1/8 inch for each inch of original measurement (an 8-inch green brick, for example, will measure approximately 7 inches when finished. All its other original dimensions will be similarly reduced).

Although the dimensions of bricks manufactured today may vary according to the company that makes them and the tradition of the locality, as well as the specifications of the architect, modern-day bricks are much more uniform than those made under the primitive conditions of Colonial times. Most early bricks measured approximately 1-3/4"x3-1/2"x7". Today's finished brick is larger and more apt to be 2-1/4"x3-1/2"x7-5/8".

The molder lays the form on a tabletop or wooden pallet, presses the wet clay into each compartment, strikes it with a wet batten* to even the surface, and clears away any excess clay. He then lifts the mold by the handles so the green bricks are left, neatly spaced, on the pallet. Green bricks should be left in the mold only long enough to solidify partially (two to three minutes) or they will stick to the wooden sides. These fresh bricks are then carried either one at a time or by sixes on the pallet (a group of six will weigh

* A flat narrow strip of wood longer than the mold is wide.

Beautiful Colonial brickwork distinguishes the Richardson house in Bath, New Hampshire. Note the variations in color. Lawrence F. Willard photo

about 60 pounds) to the drying yard.

If the mixture of clay, sand, and water is too soft for brick-making, add lime to give it body. If the mixture is too hard, add more water. The raw clay mixture should be about the consistency of jelly.

There are two kinds of brick that are made by the above process: sand-struck and water-struck. To make sand-struck brick follow the directions given by Pickering and dip the mold into a tray of fine sand before adding each new batch of clay. During the molding process some of the sand will adhere to the face of the brick and give it added texture; it will also help ease it out of the mold. Water-struck bricks are harder and present a more antique appearance. In this process the mold is dipped into a chemically softened water bath (Goodrich Co. uses water glass, an alkali) which acts as a lubricant, helping to release the molded brick.

The drying yard must be a level area fully exposed to the sun. Care should be taken in handling bricks in the green stage so as not to warp them. During hot, dry weather bricks should cure in 24 to 48 hours. They are "edged" frequently to encourage thorough, even drying. This periodic turning exposes each plane to the air. The brickmaker is dependent on nature for this phase of the operation. A hard, pelting rain will ruin freshly molded bricks, but once they have solidified rain will only retard the drying time.

By the late 19th century, most of the exposed drying yards were abandoned because of the

Roofed drying rack for green bricks.

brickmaker's lack of control over the drying process. Racks were made to accommodate the wooden pallets on which the green bricks were molded, and the racks were protected from the weather by a roof. Today, commercial brick companies have completely enclosed drying areas and force-dry bricks with the exhausted heat from the kilns.

There are two kinds of brick kilns in general use today: the scove and the beehive. The former is a temporary oven constructed of the green bricks that are to be fired. When finished, the scove kiln is dismantled and the brick sorted and carted away. This is the most practical arrangement for the homesteader. The beehive kiln is used primarily by commercial brickmakers and is a permanent oven made from specially molded and mortared bricks to form the domed sides and roof. The cavity of the oven is filled with green bricks; when these have been fired, they are removed and another batch is inserted for a future firing. The beehive kiln is usually constructed in anticipation of regu-

lar commercial production.

Once enough bricks have been dried in the yard or on racks at the homestead, you will be ready to construct a kiln. A homemade scove kiln can be built on a piece of level ground by simply stacking the dried brick from the ground up to form the bench and stepped-in arch of the kiln (see diagram). Be sure to leave plenty of space between the bricks, and make the arch wide enough to accommodate an ample firebox. The final length of the kiln will be determined by the number of bricks to be fired, but remember that it must be long enough to take the four-foot lengths of cordwood. When the kiln has been completed, it should be "faced" with already fired brick stacked around the perimeter. This facing should then be smeared with a plaster-like mixture of sand, clay, and water which will fill in holes on the outside of the kiln and help retain the heat. The daubing is retouched daily during the firing.

The scove kiln is an up-draft furnace. One end of the arch is sealed with a cast iron door, and wood is loaded into the other. When the fire is burning, the other end of the arch is sealed. In large scove kilns (sometimes they are 40 feet wide and have 20 arches), the firewood is replenished alternately from either end of the arch to get an even burn. Usually pine slabs are used to give a hot fire during the day, while slower-burning oak and maple keep the fire going at night. Temperatures reach about 1850°F. The fire is main-

THE SCOVE KILN

GREEN BRICK CONSTRUCTION

HANDLE

STEPPED-IN

DAUBING (CLAY/SAND/ WATER PLASTER TO RETAIN HEAT)

ALREADY FIRED BRICK VENEER

4' SPLIT CORDWOOD

REMOVABLE CAST IRON DOOR

tained, night and day, for about two weeks. In this type of kiln the bricks at the bottom are exposed to the greatest heat and will burn darker — from "brick" red to black. The bricks at the top of the arch will be lighter in color and softer in density. The clays native to New England generally contain enough iron to cause them to burn a deep red without additional coloring. However, the position of the brick will affect the final coloration.

The scove kiln will glow a cherry red during the firing. An early written report from Saco, Maine, advises that it will take from two days to a week of constant burning to fire brick in a scove kiln. Goodrich Brick Works fires from ten days to two weeks and allows another week for cooling before dismantling the kiln and sorting the bricks. However, their kilns burn up to 700,000 bricks at a time.

The final result is reversed in a beehive kiln (redder bricks at the top of the stack, yellower bricks towards the bottom) because this permanent furnace uses the down-draft

SIX-BRICK MOLD

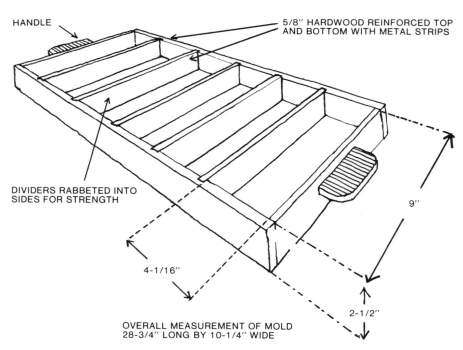

HANDLE

5/8" HARDWOOD REINFORCED TOP AND BOTTOM WITH METAL STRIPS

DIVIDERS RABBETED INTO SIDES FOR STRENGTH

9"

4-1/16"

2-1/2"

OVERALL MEASUREMENT OF MOLD 28-3/4" LONG BY 10-1/4" WIDE

method. The heat which rises to the undersurface of the kiln (made from specially shaped burnt brick) is forced down and through a gutter which runs under the kiln floor and is exhausted through a stack that may also serve an adjacent beehive. This method is used by the Densmore Brick Co., of Lebanon, New Hampshire, which has been manufacturing brick since 1817, although the rising cost of fuel oil and electricity has caused them to discontinue temporarily this part of their business. Densmore manufactured much of the brick that was used to construct the Dartmouth College campus in nearby Hanover.

Commercial brickmakers have largely converted to fuel oil for firing their bricks, but they still agree that using wood in the final stages will give the finished brick a better color.

Noggins, pluggins, and clinkins were Colonial names for the bricks that were farthest from the fire; these anemic orange or pale cream bricks were used for filler in the construction of houses and chimneys. The bench brick — those that flanked the firebox — were the most durable. These were sometimes overdone and glazed to a dark color or even burnt. In some brick bonding the burned "headers" (the ends of the brick) were alternated with the red "stretchers" (the long side) to create patterns.

Today people will occasionally pave walks and terraces with old used brick, only to find that after a winter of exposure some bricks disintegrate and have to be replaced. These are soft bricks and were never intended for outside use; apparently when they were fired the temperature was not high enough. These bricks should be saved for interior use — cellar construction, chimney and wall fillers.

Brickworks like Goodrich in Epping, New Hampshire — the sole survivor of nearly two dozen yards that manufactured bricks in that town alone — still make Colonial-sized brick for reconstruction work. Presently Goodrich is supplying bricks for the restoration work in the Faneuil Hall area of Boston.

Numerous towns throughout the six-state area supported local brickworks. During the past century, however, many brickyards have closed because of decreasing interest in brick as a building material, Meanwhile, the modern homesteader can carry on a craft that is older than the nation by making brick in his own backyard.

References

Randall, Peter "W.S. Goodrich, Inc." *New Hampshire Profiles,* Nov., 1969.

Rawson, Marion Nicholl *Of the Earth Earthy,* E.P. Dutton & Co., 1937.

Thomas, Matthew "Historical Epping, N.H.," *Raymond* (N.H.) *Times,* April 9, 1975.

Lawrence F. Willard photo

Working with a Draft Horse

DRAFT HORSE POWER, SYMBOL OF a slower age and restricted horizons, once again has become well worth practical consideration for the small holder with limited capital and no mechanical inclination. Yankee hill farms are particularly adapted to the use of a workhorse. She can easily negotiate the rocks of small, irregular meadows and can maneuver well in boggy areas that tractor drivers would hesitate to approach.

How do you go about finding such a horse? One way is to visit a livestock dealer known for his honesty, like C.H. ("Cliff") Peasley of Hillsboro, New Hampshire, who has dealt with horses all his life, as did his father. He ranges from Maryland to the Canadian border, from the coast to western New York, looking for animals to buy and sell. After we laid our cards on the table — total ignorance, limited resources, a strong will to learn —

Peasley shook his head and told us a good horse is hard to find.

"If you do locate one, it will sell for from $200 to $1000. But you won't get much of a horse for $200 today," Peasley said. Nevertheless, compared to basic tractor prices, this was a point in the horse's favor.

What age horse should a beginner look for?

"About 8 to 12 years is a good starting point. After you get experience, you can go for something younger and spunkier. Start with a proven workhorse. There is enough to learn about handling a horse without having to break bad habits."

What breed of workhorse would be best?

"Go for a grade that can do a little of everything and not too much of anything. It doesn't have to be a swaybacked plug. But avoid any horse that has been trained for pull-

ing contests. They'll take off with any equipment you hitch them to."

More important to the homesteader than cost, age, or breed is the horse's disposition. Horses can be dangerous. Finding a good-natured horse is important for the beginner, especially if he has children around.

"Working with a horse is a cooperative business. Your habits and hers will both take some getting used to. If you work her a little every day and let her see what you can do, as well as discover what the horse can do, you'll learn before you know it."

We refer to the horse as "she" as it is to your advantage to buy a mare, but even the ability to foal (in about 11 months) should not outweigh the horse's disposition. This, Peasley insists, is the prime consideration.

"For the home-production farm, there is very little a single, medium-sized workhorse can't do. It's better to hire out the heaviest work than to try to find enough for a team to do yourself. Provided you're not in a hurry, a single horse can do practically any job you set her to, including ploughing up sod land. You know, you can cover a lot of ground in a wagon. The same with a mowing machine. But you'll have to learn that you'll both need to rest."

How about the danger of working a horse too hard?

"It's possible," Peasley said. "A sweat is as good for a horse as it is for you. The only thing you don't want to do is work her to a lather. It's something you'll be able to judge when you get to know the horse."

Feed and housing and fencing are other matters to consider before you get a horse.

"Horses have to be well fed to get the best from them, just like everything else," Peasley says. "A medium-sized workhorse will take about one-quarter bale of hay morning and night and two to three pounds of grain while she's working. Some feed their horses at noon, too. Horse feed is pretty high now — same as everything else — but if you keep a cow, a horse will eat cow feed just as well." It's a good idea to supplement her diet with daily vitamins. Clean water should be available to the horse in stable or pasture at all times. A salt block should be put up on a stake in the pasture, or a salt brick installed in the stable.

How about shoes, vet bills, and the rest of those hidden costs?

"With a lot of that you have to take your chances, just as you do with any other animal. You want to get a good, sound horse to begin with. She'll have to be wormed twice a year, and you must have the vet inoculate her for encephalitis, a disease humans can get. Unless she goes onto the pavement, there's no reason for shoeing her, but you should have a farrier trim her feet regularly — at least every 2 months. Of course, some horses go through shoes quicker than children. It all depends on the horse."

Only a simple shelter is required to keep your horse happy. Even in northern New England winters, horses prefer to be outdoors, as long as there is a lean-to or some sort of wind-break. (Some farmers keep their teams housed all year; they find grass makes them sweat too

A leather draft horse collar with the wooden hames around it. The collar must fit the horse perfectly or serious shoulder galls will result.

much.) During winter storms, cold fall rains, or daytimes in the summer fly season, horses want to get under cover. Housing doesn't have to be fancy. A lean-to is fine and flooring can be packed dirt or sawdust.

Grazing in summer is best done along with or after cows. If you are planning to raise your own hay, about an acre of the best land will be enough. As for fencing, two strands of barbed wire will be enough to keep a horse in her place.

Finding a good horse that you can work with is only the first step. Next you'll have to collect harness and equipment. Used harnesses can be bought at farm auctions or from retired farmers, but like all horse equipment, these are becoming hard to find. Harness should be checked thoroughly. Many necessary repairs can be done at home. Leather should be oiled frequently with neatsfoot oil to keep it in prime condition. Unused and untreated harness will dry out, crack, and become brittle.

The same scarcity exists for horse-drawn equipment. Many items have been converted to tractor use or left to rot when the last horse left the home place. You will probably need a plough, a set of harrows, and a cultivator — also a stone boat, a mowing machine, and a wagon.

A wagon can be made in the farm shop with a set of car axles, two pairs of wheels, and some seasoned oak. Antique wagons — buggies, surreys, democrats, express wagons — in good condition are hard to find at reasonable prices. If located, they should be kept under cover, away from both rain and excessive heat.

Once enough harness and equipment have been assembled, find an experienced teamster to help you get started. The first challenge will be in sorting out the harness and learning the order and proper place for each piece. It also means learning not to undo every strap that buckles — only the key ones — so each harnessing up will be easy and orderly. And you may want to learn those names, like breeching, hames, traces, holdbacks, ridge pad, girth strap, checkrein.

You can enroll in a draft-horse school; a small number of these started up in recent years to keep the art of teamstering alive. (Write The Draft Horse Institute, Indian Sum-

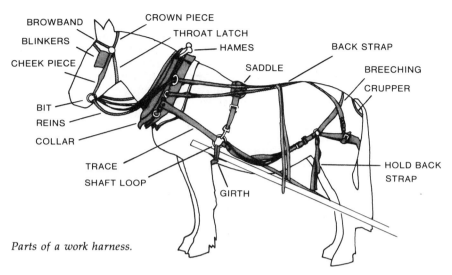

BROWBAND
BLINKERS
CHEEK PIECE
BIT
REINS
COLLAR
TRACE
SHAFT LOOP

CROWN PIECE
THROAT LATCH
HAMES
SADDLE
GIRTH

BACK STRAP
BREECHING
CRUPPER
HOLD BACK STRAP

Parts of a work harness.

mer Farm, Cabot, VT 05647 for information.) But the home-production farmer working with a single horse may find the best way to learn to handle a horse is to handle her. Persistence and regular habits are often the best teachers.

"Every horse is different," Cliff Peasley insists, "just like every man is different. With enough experience, both the horse and the man will learn to anticipate what the other needs."

Horses are large, intelligent, and very powerful. When working with a draft horse, take all precautions to guard against injury both to yourself and to your horse. Move slowly, speak conversationally in your natural voice, and make sure she knows where you are and what you are doing at all times. When moving behind a horse, place a hand on her rump or take hold of her tail. Never lift a horse's hoof without running

your hand gently down her leg first, as a warning that you are going to. Horses like to be talked to — so don't be afraid to carry on a one-way conversation — in soothing tones, of course.

A horse also likes routine. Having done something twice, she will be on the way to forming a habit. Make sure it is a habit you want her to adopt. Feeding is one thing where routine is important. Feed at regular times. Never bother a horse while she is eating. She deserves the calm to enjoy her meal as much as you do.

Bribery in the form of sugar, carrots, or grain, fed from the hand, will sometimes get your horse to do something she'd rather not (be harnessed, accept the bit, stand still, etc.), but also forms the habit of expectation. Someday, if the reward is not forthcoming, you may be nipped, trampled or kicked as a sign of

resentment. If gentleness and understanding can encourage a horse to respond, this would seem the better way. Sugar may become scarce; gentleness is a natural resource.

Some draft horses may never be well enough trained to plough a straight furrow or to cultivate without wrecking the planting with only the ploughman to guide them. If this is the case after repeated trials, use a ploughboy. Perch him astride the horse behind the saddle, and let him handle the reins. Or tell him to walk on the near side abreast of the horse's head, with the reins caught up short under the bit. If he can speak softly while walking the furrow and guiding the horse, all the better. The horse will like the immediate companionship at her ear while the working part of the job is taking place behind her.

Regional variations abound in the names of pieces of tack necessary to harness a horse for a job. There are equally various methods of procedure. Generally, though, these are the steps one takes, but they may change according to the type of harness and the temperament of the horse:

Throw on the saddle and breeching first. The saddle should be placed slightly forward of its proper place, then slid back. This will make it go with the grain of the hair and hence more comfortable. Thread the tail through the crupper and make sure it is not caught in the breeching. Buckle the girth. A horse will puff up her sides when she feels this restriction around her belly. To fool her, leave the girth buckle loose, complete the remainder of the harnessing, then come back to tighten the girth. Adjust the collar, throw the hames over it, adjusting them to the grooves of the collar, and buckle them from below. Hook the trace chains on the back strap to keep them from being stepped on until the horse is harnessed to the wagon, plough, stone boat, or whatever. The reins and bit come last, once you have taken off the halter. Thread the reins through the rings in the hames and saddle. If the horse resists the bit by raising her head too high, with one hand gently hold the bridge of the horse's nose while you enter the bit with the other. In cold weather, warm the bit in your hands or in warm water for a few minutes before putting it in the horse's mouth; after unharnessing, wash the bit in water to clean it.

Horses' faces and ears are sensitive. Rub these areas as gently as you would stroke a cat. When grooming them, use a soft cloth. Proper and regular grooming of the whole horse promotes good health and circulation, provides the attention the horse desires, and gives her a sense of pride. It should be part of the daily routine, especially when a horse is being worked.

Horses are as susceptible to colds as people are; they should never be raced back to the barn. Allow them to cool off slowly and rub them dry with soft material. *Never* let a hot, sweaty horse drink more than a mouthful of water until she is cool.

Never cut the mane and tail before fly season. These are necessary to her comfort — her natural defense against insects.

Courtesy Olive Rogers

Harvesting onions. Amherst, Massachusetts, 1915.

Root Cellars for Winter Vegetable Storage

THE MATTER OF STORING GARDEN produce using a minimum of our critical energy resources has taken on added interest in recent years. In northern climates it is possible to construct many types of temporary vegetable storage facilities: pits, trenches, pyramids of interlayered straw and root crops piled at the edge of last year's garden, barrels buried in sand, and boxes stored in the garage or basement under hay and canvas.

For those who plan to stay on their property year in and year out, permanent storage areas are more convenient and desirable.

Permanent root cellars can either be detached outdoor storage buildings or an area right under the kitchen ell. If your house has been modernized with central heating and a cement floor, this may be a major factor in determining where to store your garden produce for the winter. The advent of central heating unfortunately spelled the end of effective cellar storage of root crops which require high humidity and low temperatures.

For successful storage of vegetables, root cellar temperatures should be between 32° and 40° F., with a humidity of 60% to 75%.

Such conditions can be provided in a detached root cellar dug into a sloping bank away from the house, as was often done on early New England farms. Originally these storage cellars were made of stone, but today one can use poured concrete or masonry block walls. Earth was banked around the two sides and one end, and the roof was covered with soil to a depth of three feet. A door, usually facing south,

provided the only ventilation, and a bare earth floor controlled the humidity.

If the construction of a detached storage area is too much to undertake, anyone handy with a hammer and saw can construct a modern root cellar in the basement even if it has a cement floor. For the average family this should be about 10 by 15 feet. Use existing walls by partitioning off one corner of the cellar as far from the furnace as possible, insulate it well, and provide an outside window for ventilation.

Stud the two interior walls with 2 x 4s. These should be set 16" on center and sheathed inside and out with matched boards or composition board. Fill the spaces between the studs with loose insulation or use fiberglass batts. The ceiling should also be well insulated to keep

cold air out of the house. Install a close-fitting hinged door.

Pans of water and an occasional sprinkling from a watering can will help maintain the humidity. Light encourages sprouting; keep it out by covering the window with a shade or slatted boards.

If your house has central heating but the cellar floor is still dirt, the same kind of arrangement can be constructed. Should you have drainage problems during winter rains or spring thaws, it would be wise to lay drainage tile before constructing the root cellar. If this is not feasible, make a path of slatted boards to keep your feet dry in wet weather.

Some vegetables give off odors in storage — cabbages are the worst offenders. One way to deal with these is to bury them upside down in a

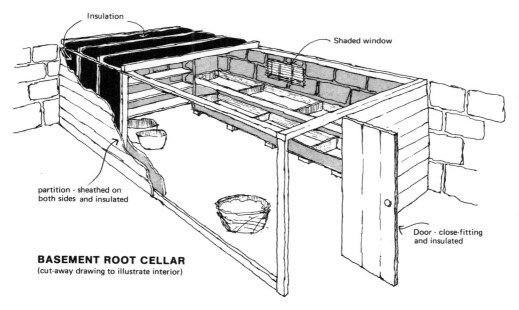

Insulation

Shaded window

partition - sheathed on both sides and insulated

Door - close-fitting and insulated

BASEMENT ROOT CELLAR
(cut-away drawing to illustrate interior)

trench along the cellar wall after they have been brought in from the garden. Another technique is to remove the stalk and outer leaves and wrap each head in newspaper, storing the wrapped heads in a box or carton. They will remain hard and firm until spring.

Here are some points to consider as you prepare to store your harvest:

1. Store only vegetables that are in nearly perfect condition. Handle crops as carefully as possible. Bruised or otherwise defective roots will encourage spoilage. While harvesting, set these aside for early use.

2. Postpone harvesting and sorting crops until the weather is settled and night temperatures are consistently low. Your storage area should already be cold before you load it with vegetables. Light frosts will not harm root crops; they often enhance the flavor. In early fall check the ventilation in the root cellar frequently.

3. After digging, air-dry root crops for several days. This hardens their skin. Loose soil can be shaken off vegetables like potatoes. If you wash vegetables like carrots and beets, be sure they are thoroughly dry before bringing them into the storage area.

4. Cut off the tops of root vegetables to within 1 inch of the crown. Rutabagas and turnips can be glazed with melted paraffin for longer keeping. Beets can be layered with *dry* fall leaves in baskets and buckets. Carrots can be bunched and stored in ventilated plastic bags or layered directly in moist sand,

sawdust, peat moss, shavings, etc. Some oldtimers core carrot crowns with the point of a knife. This deactivates the growing center which is likely to become mushy in storage unless removed. After being cored, the carrots are washed, dried thoroughly, and packed lengthwise in wide-mouthed gallon glass jars with screw-on lids. Check the underside of the lids frequently at first. If condensation appears, unpack the carrots and dry them again. These will keep for months without shriveling.

5. Sort through bins of vegetables at regular intervals during the winter to pick out those that are not keeping well. Once spoilage occurs, it can spread rapidly if not detected.

You will see from the brief summary of different methods of storing garden produce given on pp. 60 and 61, that other storage areas will have to be used for some vegetables. Onions, garlic, and shallots can be kept in mesh bags or braided and hung in the attic or an unused, darkened room. Squash and pumpkin require less humidity and warmer temperatures and can be kept on the attic floor for months. Canning, pickling, preserving, and freezing can also be done each year to preserve the full range of your harvest. However, with a permanent root cellar, a variety of produce can be kept for winter use — if stored at consistent temperatures and humidity.

One final thought. Even if you don't have a greenhouse or a sunpit, once you have a root cellar you can

SOME METHODS OF STORING GARDEN

METHOD: Leave crops in ground and cover with thick (12"-18") layer of mulch (hay, dried leaves, straw) after ground freezes to prevent it from thawing. Crops may be harvested throughout the winter and into spring.

CROPS: Carrots, garlic, horseradish, Jerusalem artichokes, leeks,parsley, parsnips, radishes, salsify, turnips.

HINTS: *Be sure to mark where each crop was growing so that when harvesting a particular crop, its location may be easily found beneath the mulch.*

METHOD: Build cone-shaped mound in well-drained area — spread layer of leaves, straw, hay, etc. on ground and place vegetables *or* fruit (do not mix) on top of the bedding in a cone-shaped formation. Cover with a layer of bedding, forming a vertical opening to the top of the mound to help control ventilation and humidity. Over the mouth and around the vertical shaft, pack firmly about 3"-4" of soil; then place a board weighted by a heavy stone or brick over the opening on top of the mound. Dig a small ditch around the mound to drain away surface water.

CROPS: Potatoes, carrots, beets, turnips, cabbage, squash, pumpkins, celery, salsify, parsnips, winter peas, apples.

HINTS: *It is best to build a few small mounds so that all the produce can be removed at one time for it is difficult to securely replace the earth covering after the ground has frozen.*

METHOD: For colder climates dig a pit (1½' to 2' deep, 4' wide at the bottom) in the area where the ground rises. Build the dirt around the perimeter of the pit with outer sides sloping away from the pit for drainage; then dig a drainage ditch around the pit to further facilitate drainage. (Remove stones from sides of the pit as they carry frost.) Pack dirt and dry, fine sand into the bottom of the pit 2"-3" deep; on top of this place a layer of vegetables no more than 1 foot deep; cover with fine sand, filling crevices between the produce, and fill to nearly ground level. Cover the sand with a mounded bed of dry leaves, straw, hay, etc. held in place by a layer of soil or by plastic sheeting held down by 1"-2" of soil. At one end of the mound, place a door on its side, slanting back. In winter, remove the door and dig in for the vegetables; then replace the door securely.

CROPS: Beets, carrots, turnips, potatoes.

HINT: *Never store root crops immediately after harvesting as they retain heat for several hours and may therefore not be as dry as possible. Allow them to remain on the ground over night to cool before storing.*

* * * * * * * * * *

The type of pit or mound you build will depend on the climate in which you live.

PRODUCE FOR YEAR-ROUND USE

METHOD: Gather tender crops before first frost and store under cover in a cool basement, cellar or dry shed. Wrap individually in paper and pack in cartons, or lay on shelves in baskets or bins lined with a bedding of dry leaves, straw, hay, etc.

CROPS: Cucumbers, squash, peppers, tomatoes (you may wish to pull up the whole plant, hang upside down in cellar, and pick fruit as it reddens).

HINT: *Check crops frequently for ripeness and possible decay.*

METHOD: Harvest in fall and store in a dark, humid, well-ventilated root cellar where the temperature remains between 35° and 45°F. Place produce on shelves, in bins or baskets lined with bedding. A hard-packed dirt floor will help maintain humidity; otherwise, leave a bucket of water within the enclosure and dampen the floor frequently. Store the produce needing warmer temperatures on high shelves, and so on downward, with those needing the coolest temperatures near the floor.

CROPS: Beets, carrots, kohlrabi, rutabagas, turnips, potatoes, cabbage.

HINT: *Cabbage, turnips and rutabagas give off odors so they should be stored away from other produce.*

METHOD: Pull up on a dry day after the tops have fallen over and leave outside for a few days to harden, then bring indoors, store in airy bags, and hang in a dry, cool, well-ventilated area.

CROPS: Onions, garlic, shallots.

HINT: *Leave stems on and braid in long strands to festoon kitchen or loft.*

METHOD: Pick when mature but still hard, and store in barrels or boxes in a moderately humid area that can be cooled by frosty night air and maintained at about 30°F.

CROPS: Apples, pears.

HINT: *Handle fruit carefully and never store any that shows bruises or decay.*

METHOD: Harvest, leaving on a few inches of stem, before frost and bring indoors. Condition at room temperature (around 70°F.) for 10-14 days to allow rind to harden and surface injuries to heal; store in rows on shelves in warm, dry basement, attic or root cellar, where the temperature can be maintained at 55° to 60°F.

CROPS: Hubbard, butternut, buttercup, acorn* squash, zucchini, pumpkin.

 * do not condition

HINT: *Despite their large size, these crops should be handled carefully and should be stored without touching each other.*

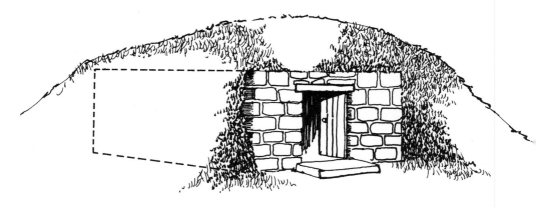

A detached root cellar built into a hill.

raise a salad crop from December to early spring without either sunlight or bother. Grow Belgian endive in your root cellar. Raise the plants from seed as a row crop in next summer's garden. When fall comes, dig the long tapering roots. Let them dry out in a convenient place undercover for about a week. Then cut off the leaves about 1 inch from the crowns. Now plant the endive roots closely in a trench in your root cellar or in deep wooden boxes filled with garden soil. Water thoroughly once. Lay 6 inches of dry hay across the top of the planting. Cover with bags or old blankets to exclude all sunlight and wait. Soon the plants will send up new growth of pointed, close-leafed spears through the straw. When about 6 inches high, cut them selectively several times a week and serve either with an oil and vinegar dressing or braised as a hot vegetable. In return for a small outlay of time and energy, this salad green will add a little tang to winter meals and serve as a reminder that spring is a distinct possibility.

References

Stocking Up ed. Carol Stoner, Rodale Press, Emmaus, Pa. 1973.

Storing Vegetables and Fruits in Basements, Cellars, Outbuildings & Pits Home and Garden Bulletin No. 119, U.S.D.A. (revised), 1970.

The Vegetable Growing Business (revised) Watts & Watts, Orange Judd Publishing Co., N.Y., 1951.

RICHARD M. BACON

The author and his family live as self-reliantly as possible on their small New Hampshire farm. Formerly a newspaper reporter and actor, he spent most of his professional life teaching at Collegiate School in New York City and Germantown Friends School in Philadelphia before a consuming passion for herbs and country living encouraged him to take up permanent residence and turn to farming and writing. A graduate of Williams College, he also studied in England at The London Academy of Music and Dramatic Art. He is the author of *The Forgotten Art of Growing, Gardening and Cooking with Herbs* and editor of *The Forgotten Art of Building a Stone Wall,* both published by Yankee, Inc., and has contributed articles to *Yankee, The Old Farmer's Almanac,* and *New Hampshire Profiles,* among other publications. Today, he and his family raise and process flowers for dried bouquets and sell herbs and herb products in the time left from tending a flock of sheep, geese, chickens, guinea hens, an all-purpose horse named Nellie Melba, and Maude, the family cow.